PLATE I

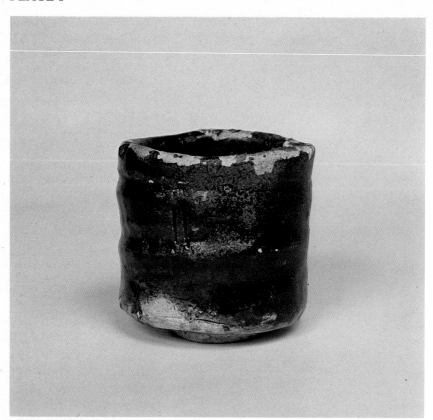

110

Tall Black Seto tea bowl

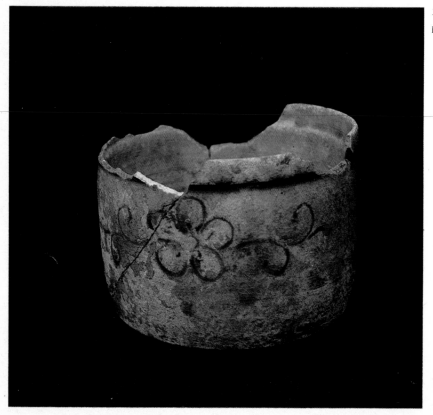

127

Deep Yellow Seto *mukozuke* with incised floral decoration

Shino and Oribe Kiln Sites

Shino and Oribe Kiln Sites

A loan exhibition of Mino shards from Toki City
at the
Ashmolean Museum, Oxford
February 1981
and the
Groninger Museum, Groningen
April 1981

by R F J Faulkner and O R Impey

ROBERT G SAWERS PUBLISHING

IN ASSOCIATION WITH

THE ASHMOLEAN MUSEUM, OXFORD

Cover illustration
403 Pair of flat Shino Oribe *mukozuke* separated by a three-legged stilt

© Copyright 1981 Robert G. Sawers Publishing/Ashmolean Museum, University of Oxford.

ISBN 0 903697 11 4 (R. G. Sawers Publishing)
ISBN 90009 084 7 (Ashmolean Museum, University of Oxford)

Reproduced and Printed in Great Britain by Hillman Printers Ltd., Frome, Somerset
Designed by Portfolio Ltd., 10 Campden Hill Square, London W8
Maps and figures by Richard Evans

Contents

List of Colour Plates

PLATE I

110 Tall Black Seto tea bowl
127 Deep Yellow Seto *mukozuke* with incised floral decoration

PLATE II

152 Decorated Shino tea bowl with design of three linked circles
202 Grey Shino waste water bowl with trellis design

PLATE III

219 Square Shino Oribe dish with design of willow tree and bridge
228 Flat Shino Oribe *mukozuke* with fan-shaped palm leaf design

PLATE IV

245 Tall Shino Oribe *mukozuke* decorated with vertical arrows and rings
298 Deep Green Oribe *mukozuke* with square mouth and plum blossom decoration

PLATE V

263 Green Oribe dish with decoration of plum blossoms floating on a stream
303 Red Oribe fan-shaped lid with tree, flower and bird decoration

PLATE VI

266 Narumi Oribe dish with overhead handle
283 Flat Green Oribe *mukozuke* with decoration of trees

PLATE VII

330 Monochrome Oribe ewer with band of incised hatched triangles around neck
337 Mino Karatsu vase with decoration of pine tree and grasses

PLATE VIII

348 Caramel-glazed jar with lug handles on shoulder and matching lid (349)

377 Ofuke fresh water jar with striated neck, fluted shoulders and flower-shaped handles

Foreword

Exhibitions devoted to Japanese ceramics are rarely held in Europe and it is with great pleasure that we are able to welcome this loan exhibition of potshards from the City of Toki. In bringing together a selection of material of known kiln site provenance and presenting it in historical sequence, a major contribution has been made towards the establishment of criteria for a more accurate attribution of pieces in museums and private collections. The choice of shards was governed both by a concern for strict archaeological evidence and by aesthetic considerations in the hope that the exhibition should be as stimulating visually as it is on an academic level.

If only for lack of material available for study in the West, Mino ceramics are far less well understood than their major position in the history of Japanese ceramics deserves. Mino is the centre of an active ceramic industry that can trace its origins back to the 7th century. The late 16th and early 17th centuries saw the production of a range of ceramics of such superlative quality that they may be regarded as one of the highest achievements of the potter's art. It is with good reason, therefore, that these wares should have been chosen as the focus of this exhibition. As

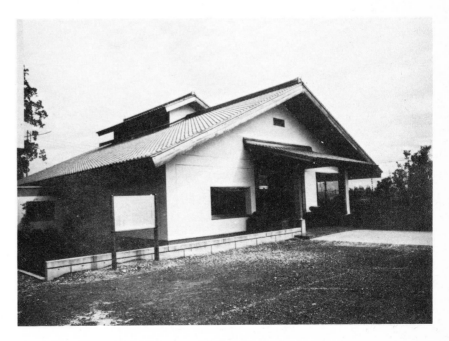

Toki City Historical Museum of Mino Ceramics

objects in themselves they are remarkable enough, but seen in their historical context they are an even more striking testimony to the highly inventive period in which they were created.

The Ashmolean Museum is deeply indebted to Mr Kajita Tatsuo, Director of the Toki City Historical Museum of Mino Ceramics (Toki-shi Mino Kotō Rekishikan), and the City Authorities for the loan of shards belonging to Toki City, and also to the Society for the Preservation of Ancient Mino Ceramics (Mino Tōso Kotōki Hozonkai) for the loan of shards from their collection. We are also indebted to the many private collectors who have lent material and to the residents of Toki City whose unsparing assistance has made this exhibition possible.

The idea of holding this exhibition was formed during a conversation between Mr Kajita, Dr Impey and Mr Faulkner in the autumn of 1979. The research on which this catalogue is based was carried out by Mr Faulkner during a two year period of study in Japan as a postgraduate student under the joint guidance of Dr Impey and Professor Narasaki Shōichi of Nagoya University, made possible by a scholarship from the Japanese Ministry of Education.

On behalf of the University of Oxford I warmly welcome this exhibition as a further link of friendship and understanding between our two countries.

David Piper
Director
Ashmolean Museum

Acknowledgements

LENDERS
The Society for the Preservation of Ancient Mino Ceramics
The Toki City Historical Museum of Mino Ceramics
Mr Okada Tadashi
Mr Okada Ryōzo
Mr Katō Takahiro
Mr Hayashi Keiichi
Mr Suzuki Akashi
Mr Fukui Tamotsu
Mr Kawai Takehiko

FINANCIAL ASSISTANCE
Messrs Sotheby Parke Bernet & Co

We would also like to acknowledge the help of
Mr Itō Yoshiaki
Mr J P Broad AIIP
and finally the continual encouragement and assistance of
Mr Kajita Tatsuo and his staff at the Toki City Historical Museum of Mino
Ceramics

Mino Kilns of the Momoyama Period

INTRODUCTION

The Momoyama period was of short duration, spanning no more than the few decades between 1573 and 1615. In spite of its brevity it was a period of utmost significance in terms of the political, economic and cultural history of Japan. Under the three successive leaders, Oda Nobunaga, Toyotomi Hideyoshi and Tokugawa Ieyasu, long years of internal war and disorder were brought to an end and final unification of the country was achieved with the establishment of the Tokugawa feudal state. Foreign trade flourished. Japan and Europe came into contact for the first time. Cities and ports grew with the expanding economy. There was great social mobility and the able and ambitious rose to prominence. Such vitality is also to be found in the arts. It was an age marked by innovation and imaginative genius, so much so, indeed, that some writers have described it as the Japanese Renaissance.

In the field of ceramics the second half of the 16th century may be thought of as a period of transition from the medieval to the early modern industry. The major developments were basically of two types. There was the growth of new kilns in many areas of Japan that had not seen ceramic production during the medieval period, while there were far-reaching changes in areas which already had an established ceramic tradition. Mino, the subject of this exhibition, is of the latter type. Mino and its neighbour Seto are of particular interest because they were the only areas to produce glazed ceramics during the medieval period, and because indications of the change from the medieval to the early modern ceramic industry can be perceived considerably earlier than elsewhere.

Mino is the former provincial name of the area that now constitutes the southern half of Gifu prefecture in central Japan (map I). It occupies the northern part of the Tōkai plain which, as one of the few extensive tracts of fertile land in Japan, has always been of major political and economic importance. Mino's fortunes followed those of the Tōkai district as a whole, though its strategic importance as one of the main gateways to the provinces of eastern Japan was also a significant factor. A detailed study of the developments of Mino's ceramic industry in the light of its economic and political history would be of very great interest. The foundation for further research has been laid in the form of many years of archaeological investigation, and one aim of this exhibition is to show Mino ceramics as they are understood by archaeologists today.

At the same time an attempt is made to demonstrate the range and variety

of Mino ceramics and the remarkable aesthetic quality of the products of the Momoyama period. The Black Seto, Yellow Seto, Shino and Oribe wares that are the climax of the exhibition show a degree of freedom and originality that has led the Japanese to regard them both as a manifestation of the spirit of their age and as one of the most important groups of wares to have been produced in the long and varied ceramic history to which their country can lay claim.

The Mino ceramic industry consists of three main groups of kilns—the Mino Sue group, the Eastern Mino group and the Ena Nakatsugawa group—which belong to an even larger complex of kilns that spreads across the entire Tōkai district (map II). We will be primarily concerned with kilns in the Eastern Mino group, though we shall begin with a more general discussion in order to understand Mino ceramics in a wider context.

THE EARLY PERIOD

Ceramics of the early period can be divided into three main traditions: the earthenware, the Sue ware and the so-called ''Shiki glazed ware'' tradition. Earthenware and Sue ware production was common to all parts of Japan, but Shiki ware production was limited to specific areas. The term Shiki ware includes both lead-glazed Aoshi wares and ash-glazed Shirashi wares. Aoshi wares were made both in the Kyoto-Nara region and the Tōkai district, but Shirashi wares were made solely in the Tōkai district. It was this monopoly over Shirashi production that was to make the Tōkai district the single most important ceramic producing area in Heian period Japan.

The beginning of high-fired ceramics in the Tōkai district was no different from other areas of Japan, occurring with the introduction of Sue technology in the late 5th century. Sue production continued until the end of the 9th century, but already by the mid-8th century potters in the Sanage area (map II) had discovered the secrets of ash-glazing. The majority of Shirashi wares were made in imitation of imported Chinese ceramics, Yüeh-type wares in particular, and they were undoubtedly made to meet the growing demand for superior products among religious institutions and the upper classes.

Shirashi wares were fired in the same sort of single chambered tunnel kilns

(*anagama*) as Sue wares, though the kilns were built in such a way that a middle to oxidising fire could be readily achieved. This, together with the use of carefully selected white clay, resulted in wares with a pale green glaze over a light coloured body, readily distinguishable from the sombre greys of Sue wares. Certain special wares were fired once without any glaze and were then refired with a green lead glaze. These are what are known as Aoshi wares.

Shirashi production began in the Sanage area and subsequently spread to the Bihoku area, reaching its height in the middle of the 10th century. In the 11th century, however, a growing and increasingly prosperous rural population came to constitute a new market for Shirashi wares. The rising demand had far-reaching results. Mass production caused an overall decline in quality. Small bowls and dishes became the main articles of manufacture. They were left partially unglazed so that they could be stacked directly on top of each other during firing, and the wide range of kiln furniture of earlier kilns was no longer used. A change in kiln design also occurred. By introducing a so-called ''flame-dividing pillar'' between the firing box and the main chamber of the kiln (fig 1), the potters were able to fire their wares more evenly and efficiently than before. These technical changes were accompanied by the spread of Shirashi technology to other parts of the Tōkai district.

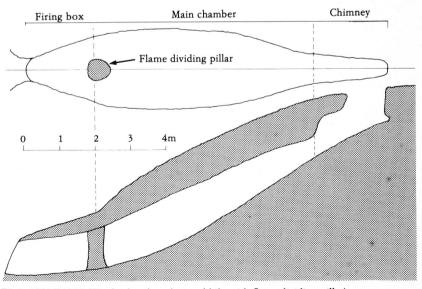

Fig.1 ANAGAMA (Single chambered tunnel kiln with flame dividing pillar)

In the 8th and 9th centuries Mino had been a major Sue producing centre with over a hundred kilns in the Mino Sue area. Production had died out in the 10th century and a lull had ensued. In the first half of the 11th century, when Shirashi technology was introduced from Sanage and Bihoku, the centre of production shifted to the Eastern Mino area. Of a total of eighty-seven known Shirashi kilns, there were forty-nine in Eastern Mino, nine in Ena Nakatsugawa and twenty-nine in Mino Sue. Some of the earliest of these produced high quality wares comparable to the best of Sanage and Bihoku products, but the vast majority belonged to the last phases of the Shirashi industry where mass production was the primary concern. Mino's main market lay in the central and eastern provinces of Japan and by the turn of the 12th century the Mino potters had almost totally monopolised the market for Shirashi wares in these areas.

The earliest shards on display in the present exhibition are examples of Shirashi ware from the Maruishi kilns in the western part of Toki City (1−13). Maruishi nos. 1 and 2 belong to the last phase of Shirashi production in Mino and can be dated to the late 12th century. They were found to be *anagama* with flame-dividing pillars, though in a poor state of preservation.

THE MEDIEVAL PERIOD

Shirashi-related Kilns

By the end of the 11th century production of lead-glazed Aoshi wares had ceased altogether. Earthenware continued to be produced widely, and except for the Tōkai district where a rough form of high-fired ware was made for local use, it remained the standard type of cheap, easily obtainable ware in use throughout medieval Japan.

We shall be concerned here, however, solely with high-fired ceramics. Professor Narasaki, the foremost authority on the subject, considers that the medieval ceramic industry began at the stage when kilns throughout Japan changed from producing a relatively wide range of products to a limited number of simple wares largely for the use of the rapidly expanding agricultural population. Glimpses of this change can be seen in the late 11th century, but the main period of transition was the 12th century. Over thirty medieval kiln groups are now known in Japan (*pace* the 'six old kilns'), and they may be divided into two main types: those that developed out of the Sue tradition and those that developed out of the Shirashi

PLATE II

152
Decorated Shino tea bowl with design of three linked circles

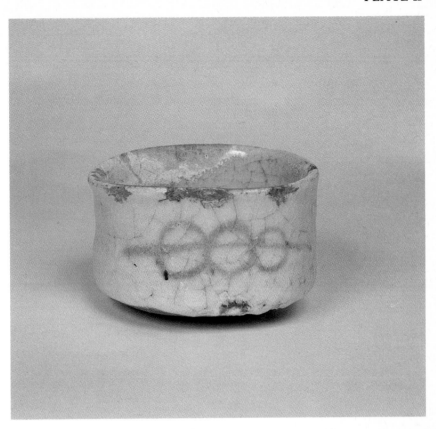

202
Grey Shino waste water bowl with trellis design

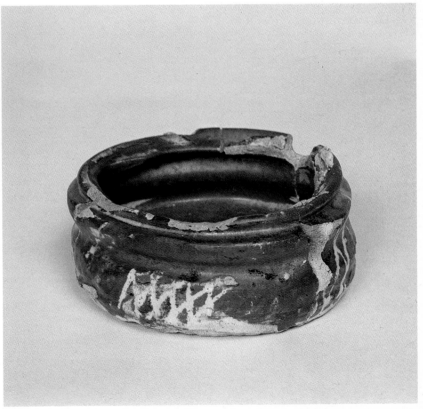

tradition. The latter kilns are known as Shirashi-related kilns and share the common feature of having flame-dividing pillars as found in late Shirashi kilns. The Shirashi-related kiln industry was, of course, based in the Tōkai district. It was different from the Sue-related kiln industry of other areas in that it did not consist solely of kilns producing *tsubo* (narrow-necked jars), *kame* (wide-necked jars) and *suribachi* (mixing mortars). There were three distinct types of manufacture: Yamachawan kilns, *tsubo, kame* and *suribachi* kilns and kilns producing high quality glazed products.

The term ''Yamachawan ware'' refers to a range of rough unglazed ceramics consisting almost exclusively of bowls and small dishes of a basic functional nature. Yamachawan production began in the Sanage and Bihoku kilns in the late 11th century and subsequently spread across the entire Tōkai district.

Tsubo, kame and *suribachi* production began in the Atsumi and Tokoname areas in the early 12th century. These kiln groups were to reach enormous proportions in the ensuing centuries and their products were distributed to many parts of Japan. Like all other *tsubo, kame* and *suribachi* products of medieval Japan these wares were not glazed.

High quality glazed wares were made in Seto. Although technically and stylistically different, Seto wares were similar to Shirashi wares in that they were made in imitation of Chinese wares and satisfied demand in areas where imported ceramics were either too expensive or unavailable. During the 13th and 14th centuries and until the spread of glaze technology into Mino in the 15th century, Seto was the sole producer of glazed ceramics in Japan.

In Mino the production of Shirashi wares continued considerably longer than in Sanage and Bihoku. This may partially be explained by the fact that Mino's main market was the eastern part of Japan where imported Chinese ceramics were relatively scarce. However, the Mino potters were forced to turn to the production of Shirashi-related wares in the latter part of the 12th century. In the Mino Sue area, production of ceramics came to a virtual end. In Ena Nakatsugawa there were about fifty kilns, twenty-one of which made *tsubo, kame* and *suribachi* wares in the Tokoname tradition during the 13th and 14th centuries. The remaining kilns in Ena Nakatsugawa, and over two hundred kilns in the Eastern Mino area made Yamachawan wares.

The earliest Yamachawan wares of the 12th and 13th centuries were relatively carefully made and are sometimes difficult to distinguish from very late Shirashi wares. In the 14th century, however, mass production caused a decline in quality which continued until manufacture ended in the early 15th century.

The small selection of Yamachawan shards on display are from Maruishi no. 3, a late 13th century kiln built in the same vicinity as the Shirashi kilns, Maruishi nos. 1 and 2 (14–19). The kiln was an *anagama* with a flame-dividing pillar and was preserved almost intact.

Introduction of Seto Technology

The change to the early modern ceramic industry is generally considered to have begun at the stage when the range of products made at established medieval kilns increased to include wares other than just *tsubo, kame* and *suribachi.* This occurred in most areas of Japan in the late 16th century. We have seen that these developments were accompanied by the growth of new kilns in areas that had not seen ceramic manufacture in the medieval period. Such changes were the result of developments in the late Muromachi period, marked above all by the rise of autonomous provincial lords and the growth of the economy. It is possible to argue that these forces affected the Seto and Mino ceramic industries considerably earlier than other areas.

By the beginning of the 15th century many hitherto active parts of the Tōkai district were no longer producing ceramics. Production of Yamachawan wares had stopped in Sanage and Bihoku and was coming to an end elsewhere. Tokoname continued to make a range of large jars, but it was in fierce competition with other major producing areas of Japan. Seto was still active, but it had passed its heyday.

In Mino, where only a handful of kilns remained active, the situation was no less bleak. It was at this stage that the technology of glazed ceramics was introduced from Seto. It is thought that Seto potters were invited to Mino by the local magnates in an attempt to encourage the rural economy. A 17th century document suggests that this may have occurred in 1436.

In view of their origins, the newly established kilns are called Seto-related kilns. A total of nine such kilns are known (map III). Except for Hinata, they are all situated in the hills south of the Toki river. Their products are almost identical to those of late Seto kilns and are often indistinguishable

from them. A wide range of products was made (20–44). They were glazed in ash, iron, or in the case of certain large functional wares, iron slip glaze. None of these kilns have yet been excavated, but they are thought to have been single-chambered tunnel kilns with flame-dividing pillars similar to contemporary Seto kilns.

In the Seto and Seto-related kilns of the 15th century, there was an overall trend away from making the large numbers of ceremonial wares typical of medieval production. The emphasis shifted to the manufacture of dishes, bowls and other functional wares. Many of these were modelled after contemporary Chinese ceramics which were imported in increasingly large quantities during the late Muromachi period. It can be seen that the Seto and Mino potters were already responding to those changes that were eventually to affect all other ceramic producing areas of Japan. It was undoubtedly because of the special nature of the wares made at these kilns that these changes in range of product occurred as early as they did, but one can nevertheless say that in Mino and Seto the transition to the early modern ceramic industry was already under way by the end of the 15th century.

THE EARLY MODERN PERIOD

Ōgama Technology
We have seen how up to this stage kilns had been little more than variations of the basic tunnel kiln (*anagama*), originally introduced from Korea as part of Sue technology. At the turn of the 16th century a completely new type of kiln, the *ōgama,* emerged in Seto and Mino (fig 2). It was not built by digging a tunnel in the hillside or by roofing a deep trench as had been former practice. The floor was set a little way into the hillside and a wide arch, supported by three or four internal pillars, was built over it. Access was no longer from the firing box or chimney but from a side entrance. The most important improvements were in the firing box. On either side of the flame-dividing pillar there was a row of smaller pillars on top of which clay-filled saggars were set. Behind these there was a step up to where the floor of the main chamber began. More wares could be placed near the front of the kiln while the rows of pillars and the domed roof combined to create a partial down-draught. The overall result was that firing could be carried out more evenly and efficiently than had formerly been possible.

It is generally thought that *ōgama* technology first developed in Seto and spread to Mino shortly after the beginning of the 16th century. For Seto the coming of the *ōgama* meant the end of a long history of medieval ceramics and production stopped in the early part of the 16th century. For Mino, on the other hand, it marked the beginning of a flourishing industry that was to reach a height in the Momoyama period.

Opinions vary as to the number of *ōgama* in Mino, but for present purposes we will consider a total of fifty-six (map III). They were active until the beginning of the 17th century when the technology of the superior multi-chambered climbing kiln (*noborigama*) was introduced from Karatsu.

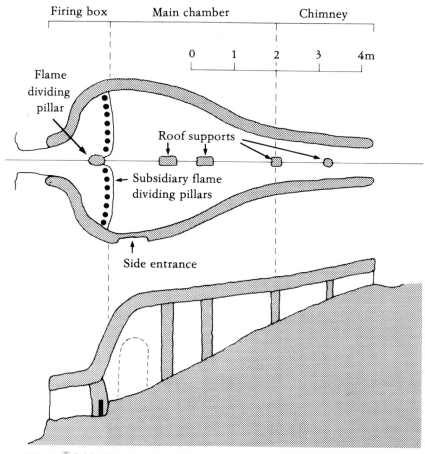

Fig.2 ŌGAMA

They have been classified into four stages. There are seven kilns in stage 1, ten in stage 2, seven in stage 3 and thirty-two in stage 4. The classification is based on a detailed comparison of various features of each kiln and its products, but in broad terms it is possible to discuss the four stages by considering the development of glaze types. Table 1 shows the main types of ware produced in Mino during the late Muromachi and Momoyama periods.

It can be seen that the variety of glazes increased from the standard ash and iron glazes to include in stage 3 Black Seto, Yellow Seto and Ash Shino, and in stage 4 pure Shino as well. The distinction between Pre-Momoyama and Momoyama kilns is made because the variety of glazes and the accompanying range of new shapes found in stage 3 and 4 kilns reflect changes in taste current among the affluent urban classes of the Momoyama period.

Pre-Momoyama Ōgama: Stages 1 and 2

The earliest ōgama known in Mino are Kamashita no. 1 and Shiroyama, both in Onada. They are called "transitional" kilns because they made both those types of ware that had been made in earlier Seto-related kilns as well as a new range of products typical of subsequent ōgama. Stage 1 kilns

TUNNEL KILN *anagama*	PRE—MOMOYAMA ŌGAMA		MOMOYAMA ŌGAMA		MULTI-CHAMBERED CLIMBING KILN *noborigama*
	stage 1	stage 2	stage 3	stage 4	
					Caramel
			Black Seto	Black Oribe	Oribe Black
	Iron Glaze				
	Iron Slip (mortars etc)				
	Ash Glaze				
		guinomide Yellow Seto	*aburagede* Yellow Seto		
			Ash Shino		
					Ofuke
					Blue & White
				Shino	Shino Oribe
					Oribe (Green etc)
					Mino Iga
					Mino Karatsu
					Mino Bizen

TABLE I

were active in the central and southern parts of the Toki river basin, while in stage 2 a slightly larger number of kilns were active over a wider area that included Mizunami, Ena and Nakatsugawa.

Stages 1 and 2 are represented by shards from Maruishi Higashi and Jōrinji Higashibora no. 1 respectively. Ash, iron and iron slip glazes were used. The ash glaze tends to have a wide crackle quite distinct from the fine crackle of Seto-related kiln products, and is often yellowish in colour. The iron glaze tends to be fairly light in colour and rather glossy. The functional nature of the majority of wares made can be seen in the shards on display (45 – 100). The main products were mixing mortars, Temmoku tea bowls and a variety of small dishes.

The blandness of these wares contrasts strikingly with the developed aesthetic quality manifest in the best of subsequent *ōgama* products. It should be borne in mind, however, that even in the most sophisticated kilns of stages 3 and 4, a large number of these simple ash and iron glazed wares continued to be made (101 – 106). It is these wares, in fact, that should be thought of as the standard output of the *ōgama* industry, while the Black Seto, Yellow Seto and Shino wares that we shall now consider should be regarded as products made for a specialized market.

Momoyama Ōgama: Stage 3
The first changes from stage 2 to stage 3 took place in Onada, the small village north of Tajimi where the Mino *ōgama* was originally established earlier in the 16th century. Amagane nos. 1 and 2 represent a continuous transition from the pre-Momoyama to the Momoyama ceramic industry. Among small dishes found at Amagane no. 1 there are examples that are distinctly yellowish in colour due to the application of iron wash beneath the ash glaze. Though technically different from the Yellow Seto glaze of later kilns, this yellow glaze represents a positive attempt to break away from the hitherto standard repertory of green and brown glazes.

Amagane no. 1 is especially important as the first kiln to produce Black Seto tea bowls, though they were not to reach maturity until Amagane no. 2. The lustrous black colour was achieved by drawing the iron glazed bowl from the kiln at the height of the firing and allowing it to cool rapidly. The long-handled tongs used to pull the bowls out of the kiln usually left marks on the glaze surface. Some of the finest examples were made at the stage 3 kilns of Sengen and Yamanokami, though production was widespread and continued through to the end of stage 4, and even into the following

noborigama period (107 – 111). A bamboo knife was used to shape and model the bowls after throwing, and to carve out the footring with the controlled spontaneity so typical of Momoyama period ceramics. The term ''Black Oribe'', used to describe tea bowls of this kind where the modelling has been taken to extremes, expresses a difference of style rather than of technique (112 – 114).

The emergence of Black Seto tea bowls was accompanied by experiments that gave rise to two further glaze types known as Yellow Seto and Ash Shino. These were closely related in that basically they were both ash glazes with a high proportion of feldspathic material added to stop the glaze from running in the improved firing conditions of the *ōgama*. In an oxidising atmosphere this mixture gave the colour of Yellow Seto and in a reducing atmosphere the greenish white colour typical of Ash Shino.

The yellow colour of oxidised ash glaze was known in Pre-Momoyama kilns and even in Seto-related kilns, but it was not consciously exploited until the kilns of stage 3. Wares with a yellow glaze that was achieved accidentally rather than intentionally are known as *guinomide* Yellow Seto wares. The term *guinomide* means ''*sake*-cup type'' and originates from the large number of small cups found with this type of glaze (124 – 125). It is used in contrast to *aburagede* Yellow Seto which refers to the intentionally made form of Yellow Seto ware. The term *aburagede* means ''fried bean curd type'' and is used because of the similarity of the granular texture of the best examples of Yellow Seto ware to that of fried bean curd. It is thought that a small amount of iron bearing clay was added to the glaze mixture to achieve this effect and to improve the colour. Some *aburagede* Yellow Seto wares have no decoration, but in most cases one finds a simple floral pattern, the effect of which is enhanced by the loose application of small quantities of copper and iron oxide that have turned green and rust brown in the oxidising fire. Yellow Seto wares exhibit the highest degree of technical skill. Most pieces were wheel thrown and have extremely thin walls (126 – 138). Apart from imparting a sense of great lightness, this allowed the green colour of the copper to stain right through the body to appear faintly on the other side, a phenomenon much prized by connoisseurs. The technique of making Yellow Seto ware first developed at the kilns of Yamanokami and Sengen and subsequently established itself at Kamashita no. 1 in Ōgaya. In stage 4, Ōgaya was to become the main centre of Yellow Seto production and apart from a few pieces found at the Yūemon kilns in Ōhira and the Motoyashiki kilns in Kujiri, examples from other kilns are very rare.

Ash Shino ware was made in relatively limited quantities, but was important as being the forerunner of the Shino wares of stage 4 kilns. They were produced at Amagane no. 2, Yamanokami and the Sengen kilns. The famous white Temmoku tea bowls once in the possession of the tea master Takeno Jōō (d. 1555) are thought to be early examples of Ash Shino ware. Though subsequently eclipsed by the production of Shino ware, manufacture continued throughout stage 4, ultimately to give rise to the Ofuke wares of the early *noborigama* period. At Yamanokami and Sengen designs were painted under the glaze in iron pigment. This was revolutionary in that it was the first use of underglaze iron in the history of Japanese ceramics. The designs on these early wares were rather simple and tended to blur due to the fluxing caused by the ash content of the glaze. By decreasing the proportion of ash in the glaze, the Mino potters were able to remedy this fault and in so doing gave rise to the almost purely feldspathic Shino glaze.

Momoyama Ōgama: Stage 4

Stage 4 kilns are by definition those that produced Shino wares. Thirty-two such kilns are known, comprising well over half the total number of *ōgama* known in Mino, and it is not without reason that Shino wares are regarded as the crowning achievement of the Mino *ōgama* industry.

It is possible to divide Shino producing kilns into two broad types. There were the first-rate central kilns of Ōgaya, Ōhira, Kujiri and Ōtomi, and the lesser peripheral kilns of Tsumagi, Jōrinji, Gōnoki and Mizunami. The Shino products of these lesser kilns were limited largely to plain or simply decorated bowls, cups and dishes. The shards from Jōrinji Nishibora no. 1 may be considered representative (141 – 148).

The kilns of Ōgaya, Ōhira, Kujiri and Ōtomi produced large numbers of these simple wares, but they also made a wide range of high quality products, the full scope of which is only partially represented by the shards on display (149 – 214). Unlike Black Seto glaze that was used exclusively on tea bowls, and Yellow Seto glaze that was used primarily on tablewares, Shino glaze was used on every conceivable type of product. Many of these had underglaze iron designs executed in free and fluid brush-strokes. Grey Shino and Red Shino wares were made by cutting through an applied layer of iron slip so that the exposed body would show white through the glaze. Pink Shino and Marbleized Shino wares were less common. Pink Shino ware was made by using an iron-bearing clay for the body, while Marbleized Shino ware was made by using two different coloured clays.

PLATE III

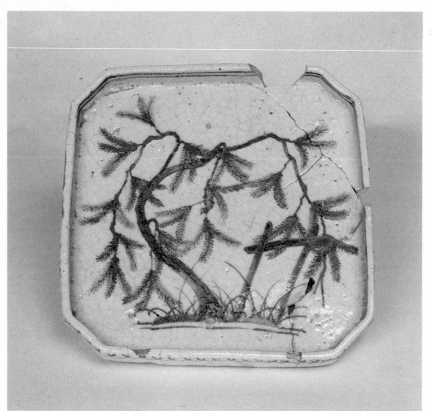

219
Square Shino Oribe dish with design of willow tree and bridge

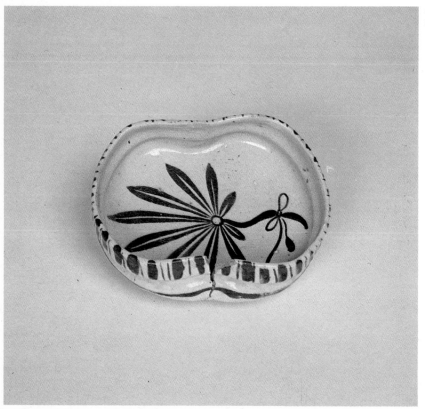

228
Flat Shino Oribe *mukozuke* with fan-shaped palm leaf design

PLATE IV

245

Tall Shino Oribe *mukozuke* decorated with vertical arrows
and rings

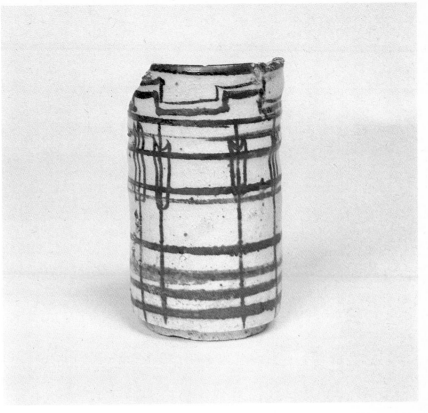

298

Deep Green Oribe *mukozuke* with square mouth and plum
blossom decoration

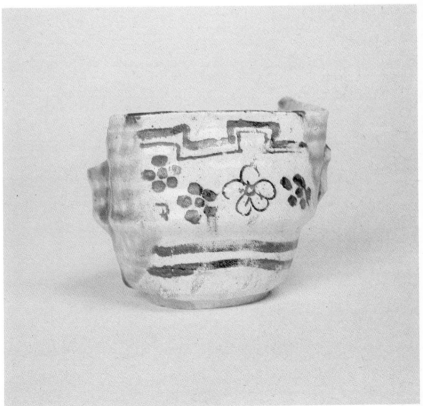

The majority of Shino wares were wheel-thrown, but they were often reshaped to give an even wider variety of forms. Square and oblong shapes were made by slab-building or through the use of moulds.

Black Seto, Yellow Seto and Shino wares are considered to be the first examples of Japanese glazed ceramics made in a purely native style. From an aesthetic point of view one must agree that they show a complete break from earlier glazed ceramics which, at their best, were never more than inspired copies of Chinese wares. At the same time, however, one cannot deny the role of Chinese ceramics as a source of inspiration for these new wares. Black Seto tea bowls seem to have been a totally Japanese innovation, but the colour combination of Yellow Seto wares, for example, is thought to have been inspired by the small three-coloured Cochin wares that were popular in Japan at that time. Certain large flat dishes are clearly based on Ming celadon shapes, while deep bowls with flat foliated rims are very similar in shape to Ming lacquer wares. Among Shino wares, *kikuzara* and *maruzara* shapes were copied from certain Chinese white porcelain dishes, while there is little doubt that imported Blue and White wares set the Mino potters in search of a white glaze that would allow underglaze painting, albeit in iron. It would be fairer to say, therefore, that the Mino potters continued to be inspired by imported Chinese wares even while pursuing the distinctly Japanese mode of expression so marvellously embodied in their work.

The Multi-chambered Climbing Kiln (*noborigama*)

Documentary evidence suggests that the technology of the *noborigama* (fig 3), was introduced from Karatsu in the first years of the 17th century. That there was intercourse between Mino and Karatsu in the late 16th century is evident from the striking similarity of designs found on Shino and Karatsu wares. Furthermore, the structure of Motoyashiki, the first *noborigama* built in Mino, is very similar to that of Handōgame, an early Karatsu *noborigama*. The new technology was undoubtedly introduced for reasons of efficiency and economy, and soon spread to other areas of Mino (map III).

Motoyashiki is renowned for the extraordinary variety of ceramics it produced and is regarded as the single most important kiln in Mino. The majority of products were made in the so-called ''Oribe'' style which is said to reflect the taste of Furuta Oribe (1544 – 1615), successor to Sen no Rikyū (1522 – 1591), and foremost tea master of his day. Oribe's style of

tea was both eclectic and flamboyant, allowing extravagances that his predecessor might have found excessive. This is discernible in the shards from Motoyashiki displayed in the present exhibition. Unlike the terms Black Seto, Yellow Seto and Shino which indicate specific types of glaze, the term Oribe refers to a variety of ceramics of a certain style, and some qualification is generally made when referring to a particular type of ware.

Both Black Seto and Black Oribe bowls were made at Motoyashiki, but the emphasis was on so-called "Oribe Black" tea bowls (115 – 118). These were similar in shape to Black Oribe bowls, but rather than being totally covered in black glaze, they had reserved panels of white, decorated with abstract designs. Many of these bowls have stamped or carved marks on the base (119 – 123). Such marks are also found on a small number of other

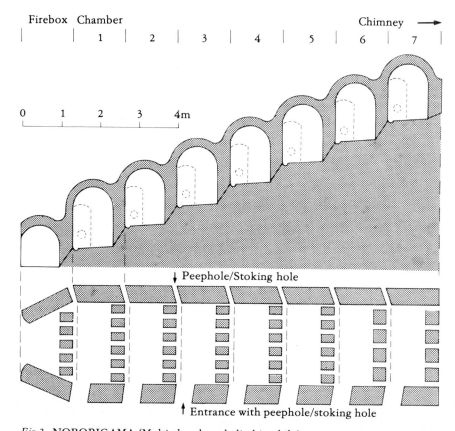

Fig.3 NOBORIGAMA (Multi-chambered climbing kiln)

wares and are thought to denote pieces made specifically for certain dealers in the capital, each dealer having his own distinctive seal.

A small number of very fine Yellow Seto wares were made. We have seen that the major Yellow Seto kilns were in Ōgaya and that there was no such tradition in Kujiri. The emergence at this stage of Yellow Seto wares of such exceptional quality reflects the extraordinary skill and versatility of the Motoyashiki potters.

Shino wares continued to be made. However, either because of improved firing conditions in the new type of kiln or because of change in glaze recipes, the glaze lost the semi-opaqueness typical of earlier Shino products and the underglaze iron designs showed through much more strongly. This allowed greater scope for underglaze painting, an opportunity that the Motoyashiki potters exploited to the fullest. The result was the range of products known as Shino Oribe ware (215 – 261).

In form, execution and decoration, Shino Oribe wares occupy an inter-mediate position between *ōgama* Shino products and Green Oribe wares, the ultimate achievement of the early *noborigama* industry (262 – 317). An extraordinary variety of shapes, a wealth of underglaze iron designs and irregularly applied patches of copper green glaze are the most distinctive features of Green Oribe wares. Certain forms were wheel-thrown, but it was the extensive use of moulds and slab-building that gave such a range of shapes. The underglaze iron designs are possibly less sophisticated than those found on Shino Oribe wares, but combined with the patches of copper green glaze, they create a sense of spontaneity which is most appealing.

Red Oribe and Narumi Oribe wares are closely related to Green Oribe wares. Red Oribe wares are made from an iron-bearing clay that is decorated with white slip outlined in underglaze iron painting. Copper green glaze is not used. In the case of Narumi Oribe wares two different coloured clays are used in the body. The white part is covered in copper green glaze like Green Oribe wares while the reddish part is decorated in white slip and underglaze iron outline like Red Oribe wares. They are undoubtedly the most complicated of all Oribe wares and possibly the most highly prized.

Monochrome Oribe wares (318 – 332) tend to be simple in shape and are called Oribe wares less for stylistic reasons than because they are glazed in the copper green characteristic of Green Oribe wares. Most forms were

wheel-thrown, though some moulded pieces were also made. The more interesting examples are decorated with neatly incised lines that appear darkly through the glaze.

The early *noborigama* are remarkable for the imitations they made of products of contemporary kilns. Into this category fall Mino Iga, Mino Karatsu and Mino Bizen wares (333–341). There was a considerable degree of mutual influence between different ceramic producing areas during the early 17th century, encouraged no doubt by dealers and tea masters in the metropolis.

The majority of early *noborigama* products we have discussed so far were made in the Oribe style. There were other products, however, of a rather different nature. Ofuke wares developed from the Ash Shino wares we have already mentioned and may be thought of as high quality functional and ceremonial wares (363–393). They were extremely carefully executed and display a remarkable degree of technical competence. In colour they tend to a greyish green and because of the fluxing caused by the relatively high ash content of the glaze, underglaze iron designs were kept fairly simple and were often applied with the aid of stencils. Underglaze cobalt blue was first used at this stage, though only at an experimental level (389–391). Related to Ofuke wares is a type of white ware that may have developed as a result of these experiments with underglaze blue (392–393).

Together with a range of functional iron-glazed wares (346–362), Ofuke wares continued to be one of the main products of Mino kilns throughout the 17th century. They far outlived Oribe wares which were already in decline by the second quarter of the 17th century, the vestigial remains of which can only just be detected in the simple bowls, dishes and flasks of subsequent kilns.

Surprisingly, the number of kilns producing true Oribe wares was limited to the eight kilns shown on map III. Of these the most important were Motoyashiki and Inkyo Higashi in Kujiri, Seidayu in Ōhira and Yashichida in Ōgaya. Kamagane and Seianji are better known for their Ofuke products while Ōtomi Higashi and Gotengama no. 1 in Tsumagi made somewhat simplified forms of Oribe ware. It is possible to regard these eight kilns as the central kilns of the early *noborigama* period. There were, in fact, many other *noborigama* active in Mino in the first half of the 17th century, but because they were peripheral kilns producing simple functional wares they have been omitted from this discussion. In the final analysis, however, it

was these kilns that were to continue as the mainstay of the Mino ceramic industry throughout the Edo period and by no means should it be assumed that Mino ceramics ended with the demise of Oribe wares.

Tea-related Wares

''Tea-related wares'' is a term that has rather special connotations, but can conveniently be applied to the range of Black Seto, Yellow Seto, Shino and Oribe wares that we have been considering. The term naturally includes all tea utensils as were used in the tea room, but is also covers the wide range of tableware and other ceramics that may have been used on occasions quite unrelated to tea drinking. They are called tea-related wares, however, because they were made for and admired by people in the metropolis whose taste in ceramics was largely governed by the leading tea masters of the time.

The use of Japanese ceramics in the tea room had first been advocated by Murata Shukō (1421? – 1502), founder of the *wabi* style of tea. Under his successors, Takeno Jōō and Sen no Rikyū, Japanese wares were used increasingly often, and it became common practice for tea masters and other dealers in ceramics to order particular wares from designated kilns. This had a major impact on the native ceramic industry, particularly Mino, the only area producing glazed ceramics in mid-16th century Japan. Black Seto tea bowls appeared in the 1550's, followed shortly afterwards by Yellow Seto wares. Shino wares emerged in the 1580's, only to be replaced by Oribe wares in the early 1600's.

We have already noted, however, that these were special wares and that even at the most sophisticated of Mino kilns a wide range of simple functional wares were also made. The ultimate concern of the Mino potters was economic viability and it was only because of the indirect patronage afforded by the affluent classes of Kyōto, Nara, Ōsaka and Sakai during the Momoyama period that they were able to develop such remarkable wares. By the end of the Momoyama period Mino was no longer the sole producer of glazed ceramics in Japan. There were stoneware kilns in Karatsu, Kyōto and Seto and new porcelain kilns in Arita, to name but a few, and trends in taste came to favour kilns other than those of Mino. The Mino potters had no choice but to abandon the manufacture of sophisticated tea-related wares and to redouble their efforts to compete successfully in the market for everyday functional ceramics.

R.F.J.F.

The Catalogue

INTRODUCTION TO THE CATALOGUE

The main categories used in the catalogue are period, type of kiln and type of ware. Finer divisions are generally made according to shape. Variations in glaze within a single type of ware are also distinguished. In order to avoid repetition, objects have been grouped together under a single catalogue entry whenever possible.

All dimensions are given in centimetres. The following abbreviations have been used:

fh fragment height
fl fragment length
fw fragment width
h height
d diameter at lip (of circular objects)
w width, generally at lip (of non-circular objects)
md maximum or minimum midpoint diameter (given in the case of objects which have a markedly concave or convex profile)
bd base diameter

Except in the case of fragment height, fragment length and fragment width where the dimensions of the actual fragment are given, the figures show the size of the object as it would have been if complete.

PLATE V

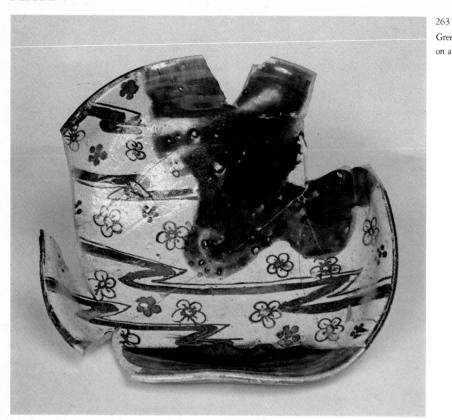

263

Green Oribe dish with decoration of plum blossoms floating on a stream

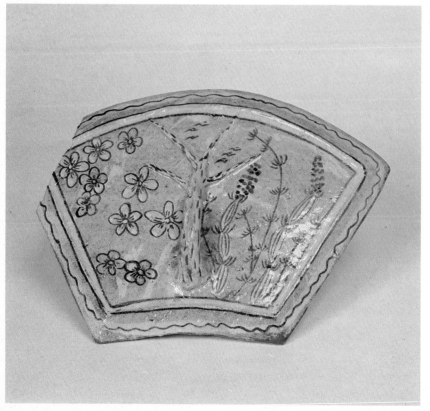

303

Red Oribe fan-shaped lid with tree, flower and bird decoration

Early Period

1–13 SHIRASHI WARES

Production of Shirashi wares began in Sanage in the mid-8th century. Although the earlier wares were purposefully ash glazed (contrast with Sue wares), it was not until the early 10th century that an almost white body was found. At this stage the technique spread to Bihoku. Clearly the search for purposeful glazing on a white body was an attempt to imitate imported Chinese ceramics. Shirashi wares were made in Mino in the first half of the 11th century. By the late 11th century the Mino Shirashi kilns had largely ceased to imitate Chinese wares and were producing good quality utilitarian ceramics. This change in range of products was accompanied by the adoption of the "flame-dividing pillar", allowing a more even distribution of heat within the kiln (see p. 17).

9

Fig.4 *Cat.No.13*

MORTARS

1–2
Mortar, thinly glazed save in the centre, where allowance is made for stacking. Such mortars are more rounded than later examples, are footed, and lack a grating surface.
1: *d23.0* 2: *bd12.0*

BOWLS

3–6
Medium-sized bowls with tall attached feet. No. 5 is totally glazed. This may have been the top piece in a stack.
3: *h6.2 d15.5 bd7.4* 4: *h6.2 d14.2 bd7.5*
5: *h5.8–6.4 d14.9 bd7.2–7.4*
6: *h5.3 d15.0 bd7.0*

7
Small bowl, also with tall attached foot, and totally glazed.
7: *h4.2 d9.8 bd6.0*

8
Miniature bowl with foliated rim.
8: *h3.0 d6.6 bd5.2*

DISHES

9–10
Small dishes, slightly foliated, with attached feet and unglazed centres.
9: *h2.5 d10.7 bd6.2*
10: *h2.4 d10.7 bd6.1*

11–12
Small dishes with straight rims.
11: *h2.4 d9.9 bd5.6*
12: *h2.1 d9.8 bd6.0*

JAR

13
Fragment of the lip of a wide-necked jar. This was the only shard of such a jar found at the excavation of the kiln site (Maruishi no. 1), suggesting the rarity of the more elaborate shapes (fig 4).
13: *d13.2*

Medieval Period

14–19 YAMACHAWAN WARES

In the late 12th century the changes in the market for ceramics that had caused the decline both in range and quality of products made at the Mino Shirashi kilns eventually obliged the potters to abandon the use of ash glaze altogether. Simple unglazed bowls and dishes, known generically as Yamachawan wares and made chiefly for the local agricultural population, became the staple produce of kilns throughout Mino.

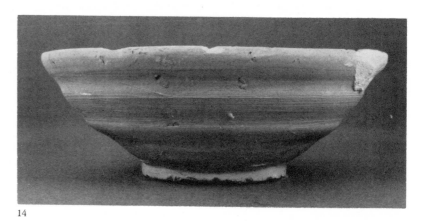

14

BOWLS

14–16
Bowls, typically of a standard size. They are well-potted and the attached feet are marked by the traces of rice hulls that were put between wares to prevent adherence during firing. No. 16 was at the top of a stack and is naturally ash glazed, as well as marked by fragments from the kiln ceiling.
14: *h5.1–5.7 d15.9 bd6.9*
15: *h5.1–5.6 d16.0 bd6.6*
16: *h5.6–5.9 d16.3 bd7.9*

17

DISHES

17–18
Small dishes, also of a standard size, with flat wire-cut bases.
17: *h2.1–2.4 d7.5–8.0 bd4.6*
18: *h1.8–2.0 d8.4–8.7 bd5.0*

POURING VESSEL

19
Fragment of the lip of a wide pouring vessel, related to Shirashi mortars (1&2). Sometimes these had a grating surface (fig. 5).
19: *fw8.8*

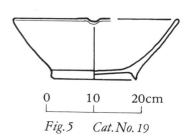

0 10 20cm

Fig.5 Cat.No.19

In the second quarter of the 15th century new techniques of glaze ceramics were introduced to Mino from Seto. Along with this came a greatly increased variety in the shapes of wares produced. These shapes imitate contemporary Seto shapes and include the fine bottles that are the last remnants of the famous Seto imitations of *ying ching mei-ping* bottles.

The glazes used were ash, iron and iron slip glaze. The ash glaze tends to be glossy and has a fine crackle. In colour it varies from a medium green (37) to an oxidised yellow (27). The iron glaze is a medium to dark chocolate brown with a semi-glossy surface. In the case of certain basic functional wares such as mixing mortars, iron slip glaze was used (42).

Technical advance includes the use of saggars for smaller wares. Larger wares continued to be fired unprotected.

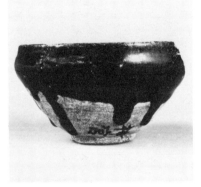

22

29

BOWLS

20–23
Temmoku tea bowls. The colour on these is plain and varies from chocolate brown to almost black. The glaze tends to run in drips towards the base. The rim is clearly marked while the side of the bowl angles in sharply towards the narrow foot. The cavetto of the foot is merely an inverted cone.
20: *h5.9 d12.1 bd4.5*
21: *not available for exhibition*
22: *h6.1 d11.6 bd4.2*
23: *h6.2 d12.5 bd4.5*

24
Temmoku tea bowl. As above, but with ash glaze.
24: *d12.4*

25–27
Flat bowls. These are invariably ash glazed, and the shape is almost that of an enlarged tea bowl. The rim is weakly marked and the foot is turned with a definite footring.
25: *h6.9 d16.2 bd4.7*
26: *h5.8–6.5 d17.0–17.6 bd5.5*
27: *h5.2 d14.7 bd4.7*

DISHES

28
Deep dish, ash glazed on the rim only and with a turned foot.
28: *h3.5 d8.9 bd4.9*

29–30
Shallow dish with ash glazed rim and wire-cut foot.
29: *h2.7 d10.8 bd5.1*
30: *h2.3 d9.8 bd4.8*

31
Shallow dish, as above, but with iron glaze.
31: *h2.4 d9.9 bd4.2*

32–33
Shallow dishes with ash glaze on rim only and with turned foot.
32: *h3.0 d10.8 bd5.4*
33: *h2.9 d11.6 bd5.5*

INCENSE BURNER

34
Incense burner of a depressed cylindrical shape. The ash glaze is applied only to the rim and there are three small attached feet.
34: *h2.3 d7.9 bd4.6*

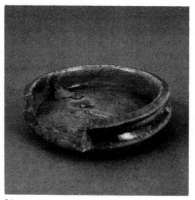

34

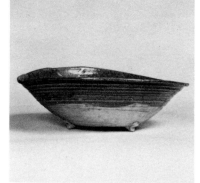

36

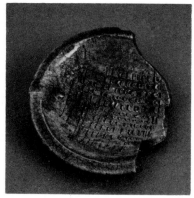

41

WATER DROPPER

35

Water dropper in the shape of a duck. Modelled figures of birds and other animals occur uncommonly at these kilns. The glaze is very dark.
35: *h4.0 w3.8×6.0 bd14.0*

FUNCTIONAL WARES

36–37

Wide flat bowls, sometimes with a grating surface. The lip is rolled slightly inwards and flattened. Only the upper half of the piece is glazed. There are three or four coarsely modelled feet attached to the edge of the base.
36: *h10.6 d24.5* 37: *h9.1 d28.8 bd13.6*

38

Wide flat bowl, similar, but with straight rim and no feet.
38: *h6.3 d24.4 bd11.8*

39

Pouring vessel. The walls are almost vertical, ending in a ridge. These vessels had attached spouts and handles.
39: *fh8.2 d16.3*

40–41

Grating dishes. These are simple shallow dishes, ash glazed only at the rolled flattened rim. The unglazed centre is scored to produce a grating surface. The spout may be attached (40) or merely thumbed out (41). Wire-cut base.
40: *h3.4 d15.3 bd7.9*
41: *h2.1 d10.8 bd4.9*

42

Mortar with characteristically straight sides and combed grating surface. The bottom is flattened and the foot wire-cut. The rim is simple.
42: *h9.8 d27.9 bd11.5*

STACKING OF WARES

43–44

Small dishes were glazed only on the rim and were stacked two or three high. They were separated by small wads of clay used in sets of four (43). They were placed in saggars with a Temmoku tea bowl on top of each stack (44). Flat ash glazed bowls were fired in stacks of four or five with five wads of clay between each bowl (figs 6 & 7).
43: *fh5.1 fw11.9* 44: *h2.8 d10.1 bd4.7*

Shapes not represented here include high quality jars, bottles, vases and candlestands for religious purposes, tea caddies and tea jars, and a range of large utilitarian wares (figs 8, 9 & 10).

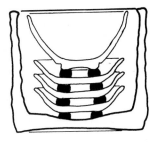

Fig.6

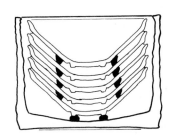

Fig.7

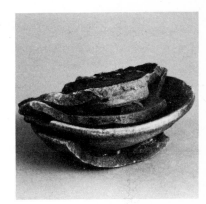

44

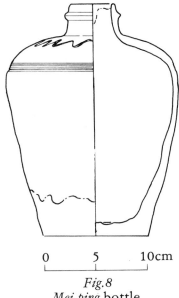

0　　　5　　　10cm

Fig.8
Mei-ping bottle

0　　　5　　　10cm

Fig.9
Buddhist altar vase

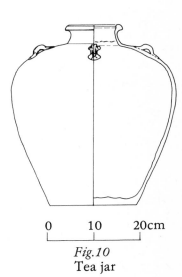

0　　　10　　　20cm

Fig.10
Tea jar

Pre-Momoyama Ōgama

45-106 ASH AND IRON GLAZED WARES

Technical advance in the form of the introduction of the *ōgama* (see p. 23) was accompanied by an increase in the range of wares produced in Mino. Certain shapes continue from the Seto-related kilns, but several new shapes reflecting imported Chinese ceramics appear.

Glazes are still confined to ash, iron and iron slip glaze. The ash glaze tends to have a wide crackle quite distinct from the fine crackle of Seto-related products. It is often yellowish in colour. The iron glaze tends to overfire, to be light in colour and very glossy.

The stacking of wares within saggars becomes increasingly complex, involving a range of sophisticated kiln furniture.

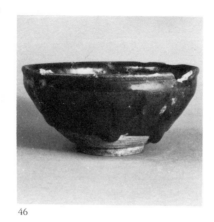

46

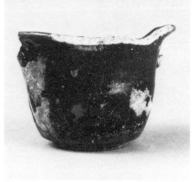

52

BOWLS AND CUPS

45-48
Temmoku tea bowls. The wares from stage 1 kilns are neatly executed and have an elegantly finished lip (45 & 47). Wares from stage 2 kilns tend to be squat with a heavy looking lip (46 & 48). The foot may either have a definite footring, or be the simple inverted cone found on Temmoku tea bowls of the Seto-related kilns. Some bowls have a thin iron slip to darken the body (46 & 47).
45: *h6.0 d12.0 bd4.2*
46: *h5.1–5.5 d11.4 bd4.3*
47: *h6.0 d12.3 bd4.1*
48: *h6.0 d11.5 bd4.0*

49-50
Round bowls in ash or iron glaze with either turned or attached feet.
49: *h5.9 d11.9 bd4.9*
50: *h5.6 d11.2 bd 5.2*

51-52
Small cups, varying in shape and with either ash or iron glaze.
51: *h3.5 d6.7 bd2.5* 52: *h5.6 d7.9 bd3.5*

SMALL DISHES

53-55
Maruzara, ash or iron glazed with attached foot and simple lip.
53: *h2.4 d10.8 bd6.2*
54: *h2.6 d10.6 bd5.8*
55: *h2.5 d10.7 bd6.5*

56-57
Small *maruzara,* ash glazed with attached foot and simple lip.
56: *h2.1 d8.5 bd4.9* 57: *h2.2 d8.5 bd4.7*

58-59
Maruzara with raised unglazed centre. Ash glazed with turned sunken foot.
58: *h2.5 d10.4 bd5.6*
59: *h2.2 d10.2 bd4.6*

60-61
Ryōzara, iron glazed only with everted lip and turned sunken foot. These are found only in stage 1 kilns.
60: *h2.5 d10.3 bd6.0*
61: *h2.0 d10.5 bd5.2*

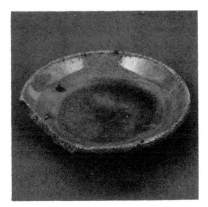

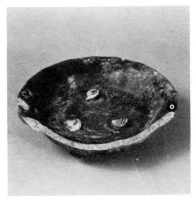

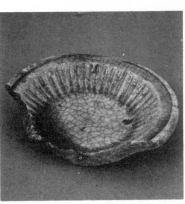

53

62

67

62–65

Hidazara, ash or iron glazed with everted foliated lip. Sometimes the centre is left unglazed. Usually the foot is sunken and unglazed.

62: *h2.4 d10.1 bd4.9*
63: *h2.3 d10.0 bd5.3*
64: *h1.9 d11.2 bd5.8*
65: *h3.1 d10.8 bd6.0*

66–70

Orifuchizara. Ash or occasionally iron glazed. Made in imitation of small Chinese celadon fluted dishes, though not always actually fluted (66). Some have stamped designs such as flowers (68) in the centre. Some examples have unglazed centres. These dishes are not found until stage 2 kilns.

66: *h2.5 d11.0 bd6.0*
67: *h2.4 d11.3 bd6.2*
68: *h2.7 d11.7 bd5.8*
69: *h2.2 d11.4 bd6.2*
70: *h1.8–2.1 d11.6 bd6.3*

71–72

Ryōzara with foot. Ash glazed types found only in Stage 2 kilns. Some examples have raised unglazed centres.

71: *h1.9 d11.1 bd6.5*
72: *h1.7–2.0 d10.0 bd5.7*

INCENSE BURNER

73

Small, ash glazed incense burner. This example does not have the three attached feet typical of incense burners.

73: *h2.9 d5.8 bd3.8*

WATER DROPPERS

74–75

Iron glazed water droppers. The larger examples have loop handles and may have had lids.

74: *h5.8 d3.9 md8.8 bd5.7*
75: *h3.2 d2.3 md5.3 bd3.0*

SMALL CONTAINERS

76–78

Ash and iron glazed containers. The larger rounded shape is more common.

76: *h4.2 d3.4 md5.0 bd3.0*
77: *h4.8 d5.6 md8.3 bd4.9*
78: *h5.6 d3.7 md7.7 bd4.9*

BOTTLES

79–80

Iron glazed bottles. No. 80 has ash glaze splashed over the iron glaze as decoration. The shape is usually round-bellied and the neck ends in a wide everted lip.

79: *fh20.5 md11.8 bd8.0*
80: *fh11.0 d6.3*

FUNCTIONAL WARES

81

Spouted vessel, almost vertically sided, with turned foot. Invariably iron glazed. The spout would have been attached.

81: *h9.6 d13.8 bd11.2*

82

Large unglazed dish. These are usually made from a special iron-bearing clay that fires very hard.

82: *h6.8 d30.8 bd16.6*

83

Oil lamp in the shape of a shallow dish and made of iron-bearing clay. These pieces are very carefully made and have concentric raised ribs, possibly to prevent the wick slipping.

83: *h2.2 d10.4 bd4.7*

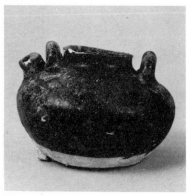

74

Fig.11

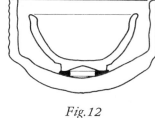

Fig.12

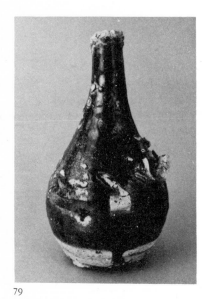

79

84

Mortar, covered in an iron slip glaze and with combed grating surface. The heavily modelled rolling lip is characteristic of mortars from *ōgama.*
84: *h11.8 d29.4 bd10.8*

STACKING OF WARES

85–100

i) In stage 1 kilns Temmoku tea bowls were fired together with iron glazed *ryōzara,* one of each per saggar (85 & fig 11). In stage 2 kilns the *ryōzara* was replaced either by an iron glazed *hidazara* (86) or an ash glazed *orifuchizara* with unglazed centre (87). The small dish sat in the saggar on a ring of clay (93–95), while the Temmoku tea bowl was separated from the dish by three small wads of clay in the case of iron glazed *ryōzara* and *hidazara,* or by a ring of clay in the case of ash glazed *orifuchizara.* Some Temmoku tea bowls, however, were fired singly in round-bottomed saggars which appeared for the first time in stage 2 kilns (fig 12).

ii) *Maruzara, orifuchizara, hidazara* and ash glazed *ryōzara* were stacked in two ways. Those with unglazed centres were stacked four high with rings of clay in between them. On the top a fifth, fully glazed dish was placed (fig 13). A more complicated method was devised for firing fully glazed dishes, two per saggar. One dish was placed at the bottom of the saggar on a clay ring. The second dish sat on a so-called *hasamizara* (88 & 89) which was supported in the saggar by special stilts (91 & 92) so that it did not touch the lower dish (97, and fig 14).

iii) Small *maruzara* seem to have been somewhat special in that they were fired individually in small flat saggars (98).

iv) Mortars were stacked in the rear of the kiln along with other large wares. They were separated from each other by four wads of clay (96). Large cylindrical wares (e.g. 81) were stacked in piles and were used like saggars in that smaller wares were placed inside them during firing.

87

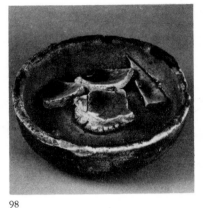

98

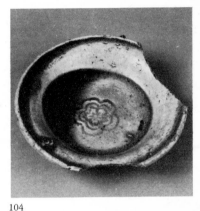

104

v) Low stilts were set on the kiln floor to give a horizontal base on which the saggars could be stacked (100).

85: *fh4.1* 86: *fh6.4* 87: *fh6.5*
88: *h2.6 d10.5 bd6.1*
89: *h2.4–2.7 d10.9 bd6.2*
90: *fh6.2 fw11.0* 91: *w3.3×5.1*
92: *w3.6×4.8* 93: *h1.0–1.3 d3.7*
94: *h0.6 d4.1–4.5* 95: *h0.7 d4.1*
96: *h3.8 d4.1–4.5*
97: *h10.1 d14.2 bd13.2*
98: *h3.9 d12.5 bd7.1*
99 *h4.7 d11.0 bd4.8* 100: *h4.2 d8.5*

EXAMPLES OF ASH OR IRON GLAZED WARES FROM MOMOYAMA ŌGAMA

The majority of wares made in Pre-Momoyama *ōgama* continued to be made throughout the 16th century. They were mainly for daily use and when we discuss the later kilns, we should remember that these wares were in continual production and are found at almost all kiln sites, save only the very latest Shino producing kilns.

101–102
Temmoku tea bowls continued to be made throughout the 16th and 17th centuries.
101: *h5.7 d11.6 bd4.8*
102: *h4.9 d10.3–10.6 bd4.1*

103
Sake cup in the form of a miniature Temmoku tea bowl.
103: *h2.7 d5.7 bd2.5*

104–105
Orifuchizara.
104: *h2.6 d11.3 bd6.0*
105: *h1.8 d10.8 bd5.9*

106
Incense burner.
106: *h3.9 d5.4 bd4.6*

Shapes not represented here include vases for religious purposes, tea caddies and a range of large functional wares.

Fig.13

Fig.14

Momoyama Ōgama

107–123 BLACK SETO AND RELATED WARES

In about 1550 we find the first examples of ceramics specifically made to order for tea ceremony use. These are the heavy-looking Black Seto tea bowls, the characteristically cylindrical shape which is new to Japanese ceramics and has no known prototype. In very late *ōgama* they develop into Black Oribe tea bowls, and in early Mino *noborigama* into Oribe Black tea bowls.

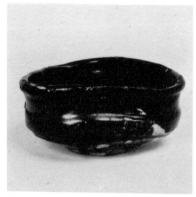

113

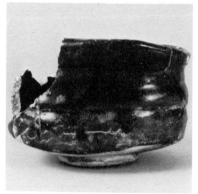

114

BLACK SETO WARES

107
Simple, low-footed, flat-based cylindrical Black Seto tea bowl.
107: *h7.9 d12.2 bd5.8*

108
Fragment showing the depressed centre typical of these bowls.
108: *bd6.0–6.3*

109
Fragment showing the quick and simple carving used on the feet of these bowls.
109: *fw10.9 bd5.4*

110
Tall Black Seto tea bowl. The throwing marks are deliberately left showing.
110: *h11.0 d11.4 bd5.0*

111
Fragment showing one of the more complicated ways of executing a foot.
111: *bd6.6*

BLACK ORIBE WARES

112–114
Black Oribe tea bowls showing in exaggerated form the distortions and modelling of the thrown form first seen in Black Seto wares. The shape tends to that of an irregular oval (*kutsugata*—lit. "shoe-shaped") and the bowl is squat and has a strong thick lip. Occasionally these wares fire brown instead of black (114).
112: *h7.1 w10.8×16.7 bd6.1–6.8*
113: *h7.4 w14.1×15.3 bd6.1*
114: *h8.1–8.9 w12.9×14.8 bd6.2*

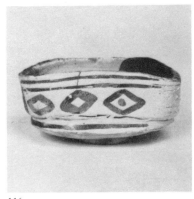

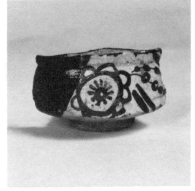

116 117 120

ORIBE BLACK WARES

115–118
Oribe Black tea bowls. These are invariably shoe-shaped and have reserved panels of white glazed areas with underglaze patterning in iron.
115: *h7.3 fw11.7×14.0 bd6.3*
116: *h6.8 w11.3×14.4 bd5.8*
117: *h7.6 fw10.0×11.0 bd6.2*
118: *h8.6 bd5.6*

119–123
Fragments with marks, thought to be those of customers, scratched or stamped onto the foot of Oribe Black tea bowls.
119: *bd6.0* 120: *bd6.0* 121: *bd6.8*
122: *fw10.0 bd5.6* 123: *bd5.4–6.1*

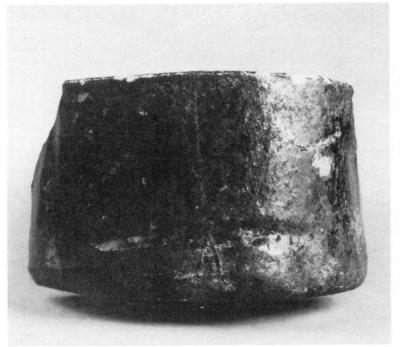

107

The yellow colour of these finely made wares is produced by the oxidation of an ash glaze. This effect was known in Seto-related kilns of the late 15th century (27) and in Pre-Momoyama *ōgama* (68). Here it appears in two forms, the apparently experimental *guinomide* type and the more sophisticated *aburagede* type. These latter wares are finely potted and have a thin granular glaze. They may be decorated with incised or stamped floral patterns which are picked out in iron brown and/or copper green.

126

GUINOMIDE TYPE

124–125
Hexagonal *sake* cups, thickly potted and thickly glazed.
124: *fh4.1 bd4.9* 125: *h6.6*

ABURAGEDE TYPE

126
Low wide bowl with flattened rim and decoration of flowers in green and brown.
126: *h5.5 d17.8 bd11.4*

127
Deep *mukozuke* with vertical sides and incised floral scroll decoration.
127: *h8.3 d11.1 bd6.0*

128–134
Fragments of bowls, dishes and *mukozuke* showing various shapes and decoration. 132 is the base of a low bowl with a stamped *fuku* mark in the centre. 134 is the chrysanthemum-shaped knob of the lip of a deep bowl.
128: *h5.2 d7.0 bd5.8* 129: *fh4.6 d13.3*
130: *fh5.5 w6.4 bd5.3*
131: *fw5.8 × 13.8 bd10.0*
132: *fw10.6 × 13.0*
133: *fw11.0 × 14.0 bd7.8*
134: *fw8.5 × 8.5 d(knob)7.8*

135
Square *mukozuke* with incised floral pattern.
135: *h5.4 w13.0 bd8.5*

136
Drum-shaped vase, undecorated.
136: *h20.8 d12.4 md10.0 bd7.8*

137
Fresh water jar of uncharacteristically coarse form. The flattened rim is probably intended to take a lid.
137: *h7.4 d17.9 bd15.5*

138
Lampstand with *aoi*-leaf shaped piercing.
138: *h16.5 d7.6 bd14.2*

135

138

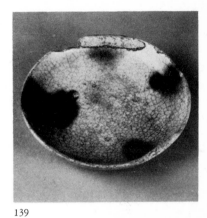

139

YELLOW SETO-DERIVED WARES

These are found in the last phase of production at Motoyashiki and are more typical of peripheral *noborigama*.

139
Maruzara with splashes of copper green.
139: *h2.5 d11.7 bd7.2*

140
Kikuzara.
140: *h3.2−3.6 d13.5−13.8 bd6.9*

Shapes not represented here include tea bowls (rather rare), incense burners and incense boxes, while the range and variety of bowls, dishes and *mukozuke* is very great indeed.

136

141–214 SHINO WARES

Shino wares may be regarded as the highest achievement of the Mino *ōgama*. First produced in the 1580s, they were made at a large number of kilns that can be divided into two types: the central and the peripheral kilns. The peripheral kilns produced a limited range of simple bowls and dishes, while the central kilns produced a large number of more sophisticated "tea-related wares" as well. The term "Shino" refers to the almost purely feldspathic white glaze common to Plain (*muji-shino*), Decorated (*e-shino*), Grey (*nezumi-shino*), Red (*aka-shino*), Pink (*beni-shino*) and Marbleized (*neriage-shino*) Shino wares. (See p. 28)

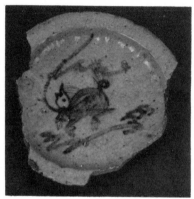

155

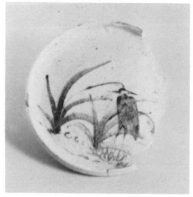

156

SHINO WARES FROM PERIPHERAL KILNS

These tend to be plain, though they occasionally have underglaze iron decoration (*e-shino*).

SMALL DISHES

141–144
The three common types are represented here: that with a simple lip (141), that with a flared lip (142 & 143) and the *kikuzara* (144). The type with the simple lip is occasionally decorated.
141: *h3.2 d13.6 bd8.0*
142: *h2.2 d12.4 bd6.4*
143: *h2.9 d12.5 bd7.1*
144: *h2.8 d12.5 bd7.2*

FLAT DISHES

145–147
Simple flat dishes (*mukozuke*) with straight vertical sides, in three sizes.
145: *h6.3* 146: *h3.7 d13.2 bd8.2*
147: *h2.5 d12.0 bd6.8*

MUKOZUKE

148
Deep *mukozuke* with straight vertical sides.
148: *h6.1 d9.6 bd6.0*

SHINO WARES FROM CENTRAL KILNS

These include all six types of Shino ware. 149–198 are nearly all Decorated Shino, the most common type of Shino ware found at these kilns, though simple bowls and dishes tend to be plain (149, 151, 153 & 154). 192 & 193 are examples of the rather rare Pink Shino. 199–211 are examples of Grey and Red Shino wares.

BOWLS AND CUPS
Plain and Decorated

149
Large round undecorated bowl.
149: *h6.8 d11.3 bd5.6*

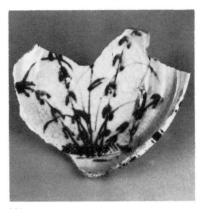

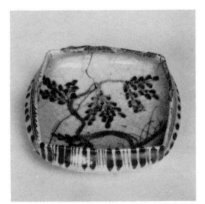

161 163 163a

150
Small round bowl, decoration of grasses.
150: *h5.0 d8.0 bd3.5*

151
Small, undecorated, *sake* cup with slightly flaring lip.
151: *h3.6–3.9 d4.9–5.2 bd3.3*

152
Tea bowl. The low profile is a common one, though other shapes exist. The decoration here is of three circles linked by a horizontal line.
152: *h8.4 d13.4 bd5.0*

SMALL PLAIN DISHES

153–154
Small undecorated dishes of two shapes, demonstrating the occurrence in central kilns of the common shapes of the peripheral kilns.
153: *h2.9 d12.5 bd6.9*
154: *h2.7 d12.8 bd7.5*

MEDIUM AND LARGE DISHES
Decorated Shino

155
Round dish with flat foliated rim and interior fluting. Decoration of a dog.
155: *h3.1 d19.5 bd9.9*

156
Round dish with low vertical sides. Decoration of a heron among reeds.
156: *h3.0 d18.5*

157
Round dish with low vertical sides. Raised slip decoration and reeds in underglaze iron.
157: *h2.3 d20.3*

158
Square dish with canted corners and low vertical sides. Decoration of crane under a pine tree.
158: *h4.0 w24.2*

159
Round dish with floral decoration.
159: *h4.0 w16.6*

DISHES WITH COMPLEX RIMS
Decorated Shino

160
Deep squared dish with decoration of a pine tree.
160: *h5.0 fw8.0 × 15.0*

161
Deep squared dish with decoration of reeds and grasses.
161: *h4.8–5.1 w15.8 bd12.0*

162
Deep squared dish with decoration of bush-clover and other plants.
162: *fh5.5 fw16.5 bd12.1*

163
Deep squared dish with decoration of a leafy tree. Vertical stripes on exterior rim.
163: *h4.8 w15.2*

163a
Deep squared dish with floral decoration.
163a: *h5.8 w16.5*

167

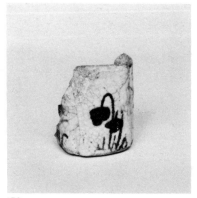

173

174

DISH WITH FOLIATED RIM
Decorated Shino

164
Deep dish with internal decoration in *fuyo-de* style, external decoration of autumn grasses and small applied studs typical of this and certain other Shino shapes.
164: *w15.6*

DISHES WITH ROLLED LIP
Decorated Shino

165
Large deep moulded dish. Squared, with sides decorated in *fuyo-de* style motifs, the centre with a pine tree.
165: *h7.4 w23.7*

166
Medium-sized deep moulded dish (underfired). Squared, with modelled and painted *fuyo-de* style sides, the centre with a bridge and thatched hut.
166: *h5.6 w15.4*

DISHES AND MUKOZUKE SQUARED STRAIGHT SIDES
Decorated Shino

167
Medium-sized dish with low sides and design of bridge.
167: *h5.3 w14.0*

168
Deep medium-sized dish with indented corners and exterior designs, different on each side, of plants and waves.
168: *h6.9 w12.4 bd8.6*

169
Tall *mukozuke* with landscape decoration.
169: *bd6.8*

170
Small *mukozuke*, the sides slightly flared and the lip curved (underfired). Decoration of various plants.
170: *h5.4 w10.0 bd5.5*

171
Deep *mukozuke* with indented corners and lattice decoration.
171: *h9.0*

172
Deep *mukozuke* with indented corners and floral and lattice decoration.
172: *h8.5 w8.5 bd7.2*

173
Small deep *mukozuke* with indented corners, fern and floral decoration.
173: *h8.5 w5.0*

CYLINDRICAL MUKOZUKE
Decorated Shino

174
Medium-sized *mukozuke*, the lip curved outward and rolled. Decoration of arrow-wort.
174: *h8.8 bd5.2*

175
Medium-sized *mukozuke* with net and flower design.
175: *fh8.5*

176
Small *mukozuke* with plant design.
176: *fh5.8 bd5.0*

177
Small *mukozuke* with decoration of arrow-wort.
177: *h7.5 bd5.4*

PLATE VI

266
Narumi Oribe dish with overhead handle

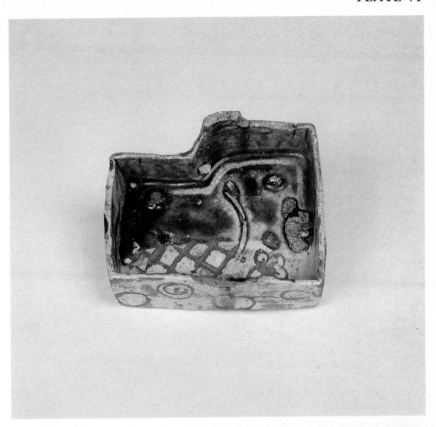

283
Flat Green Oribe *mukozuke* with decoration of trees

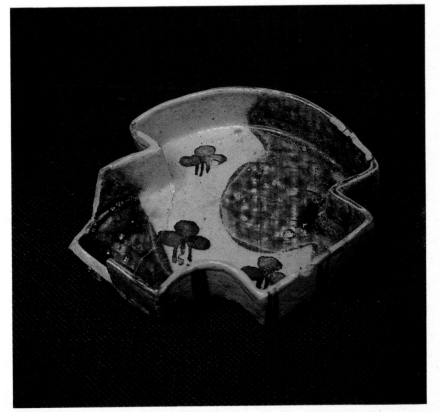

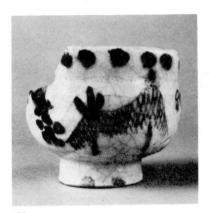

178

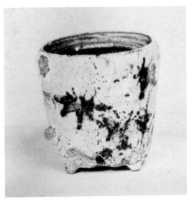

179

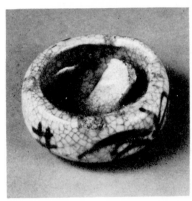

180

MUKOZUKE WITH STEM FOOT
Decorated Shino

178
Mukozuke with decoration of drying fishing nets.
178: *h8.0 w9.0 bd5.1–5.4*

INCENSE BURNER
Decorated Shino

179
Incense burner with square base and four small feet. The round rim is galleried for a lid. Decoration of autumn grasses.
179: *h8.9 w8.6 bd6.6*

OIL LAMP
Decorated Shino

180
Round oil lamp with inrolled lip which is partly cut away opposite a raised slope that holds the wick. Design of trees and grasses.
180: *h3.5 d6.5 md9.0 bd5.4*

SHAPES AND DECORATION
Decorated and Pink Shino

181–189
Rims of bowls, dishes and *mukozuke*.
181: *fw9.9* 182: *fw8.7* 183: *fw5.4*
184: *fw5.8* 185: *fw4.7* 186: *fw4.3*
187: *h2.6 fw10.1* 188: *h2.5 d16.5*
189: *fw10.0*

190–192
The three typical types of attached feet found on dishes, bowls and *mukozuke*.
190: *h5.6 fw8.4* 191: *h3.1 fw8.9*
192: *fw8.2*

193–198
Examples of painted decoration in underglaze iron.
193: wheels on a Pink Shino body.
198: paulownia painted in underglaze iron with sgraffiato. This is very rare.
193: *fw11.3* 194: *fw6.0*
195: *h6.5 fw6.5* 196: *fw7.2* 197: *fw4.8*
198: *fw7.0 × 7.0*

DISHES WITH COMPLEX RIMS
Grey Shino

199
Deep squared dish with cut-away corners and decoration of drying fishing nets and water birds.
199: *h3.4–4.6 w15.2 bd13.4*

200
Deep squared dish with indented corners, decoration of *susuki* grass.
200: *h4.2–4.5 w17.8*

201
Deep foliated dish with decoration of autumn grasses.
201: *h5.2 d11.0–12.5*

WASTE WATER BOWL
Grey Shino

202
Low waste water bowl with rolled lip and decoration of trellis.
202: *h7.2 d16.2 bd16.5*

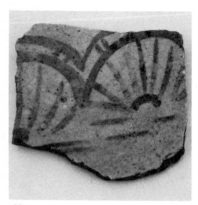

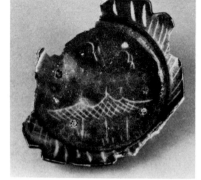

193 199 213

SHAPES AND DECORATION
Grey and Red Shino

203–206
Examples of the complex rims of Grey
Shino dishes.
203: *fw11.0* 204: *fw7.5* 205: *fw6.4*
206: *fw9.3*

207–211
Examples demonstrating the thinning of
the glaze to produce the red effect typical
of Red Shino wares.
207: *fw9.2* 208: *fw9.1* 209: *fw4.6*
210: *fh4.4* 211: *fw9.0*

STACKING OF SHINO WARES

212–214
Examples showing the use of cone-
shaped spurs typical of the Shino kilns.
Simple dishes were usually stacked four
deep with an ash glazed *maruzara* on top
(212 & fig 15). Examples 213 and 214
show that even the more sophisticated
pieces were stacked one within the other.
(Note spur marks in, for example, nos.
167, 169 & 199).
212: *fh6.0 fw12.5* 213: *fh4.5 fw14.2*
214: *fw10.9*

Shapes not represented here include
vases, fresh water jars, incense burners,
incense boxes and flat ewers with
overhead handles. The range and variety
of bowls, dishes and *mukozuke* is only
partially represented.

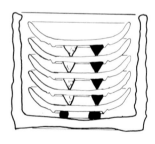

Fig.15

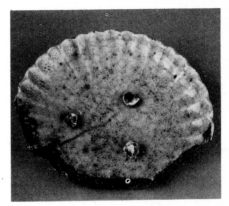

144

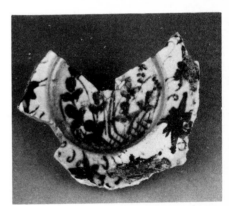

162

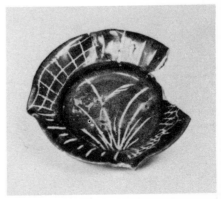

201

Early Noborigama

215–261 SHINO ORIBE WARES

Improved firing conditions due to the introduction of the multi-chambered climbing kiln, the *noborigama,* from Kyushu, and the use of a less opaque glaze allowed greater scope for detailed underglaze painting. The technique of these wares is based on the Shino tradition, while stylistically they parallel and possibly foreshadow Green Oribe wares. This is best demonstrated in the flat *mukozuke* (225–235) where some examples are distorted in shape after wheel throwing while others are mould-made in irregular shapes. Comparable Green Oribe pieces are always mould-made.

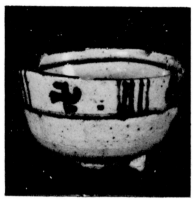

215

BOWLS

215
Simple round bowl with exterior band of Buddhist symbols.
215: h5.5 d9.2 bd3.2

216
Conical shaped bowl with foliated rim, the foot strongly formed. The exterior with radial and the interior with concentric lines.
216: h6.9 d13.5–15.2 bd5.2

SMALL DISHES

217
Small *maruzara* with band of geometric decoration and central abstract floral decoration. This type of decoration is found both in late Shino *ōgama* and at Motoyashiki.
217: h2.5–3.1 d11.8 bd6.6

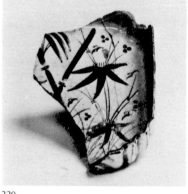

220

MEDIUM/LARGE DISHES

218
Very large dish with everted lip, design of creeping plant.
218: h8.3 d34.7 bd19.0

219
Square dish with canted corners, bracket feet and vertical sides. Decoration of willow tree and bridge.
219: h4.5 w25.2

220
Squared dish with stepped corners and vertical sides. Decoration of birds, flowers and bamboo.
220: h6.6 w18.5

221
Fragment of a very large dish with calligraphy, possibly a poem.
221: fw9.1

222
Circular dish of a slightly later type, coarsely decorated with temple and fishermen in a landscape.
222: fw16.3 bd9.2

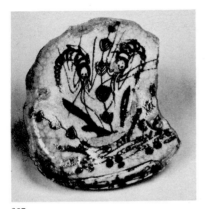

227

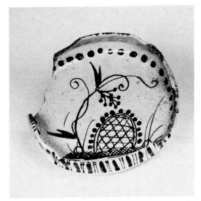

231

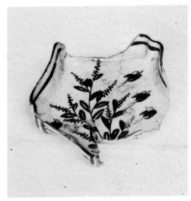

232

SHAPED DISHES

223
Melon-shaped dish, with lines following the shape of the fruit (underfired).
223: *h4.5 fw10.7*

224
Squared dish with complex rim. Decoration of lines on the sides and pine tree in the centre.
224: *h6.4 w13.7 bd5.6*

FLAT MUKOZUKE

225
Moulded *mukozuke* with decoration of pine trees on a mountainside.
225: *h4.1 fw11.7×14.0*

226
Moulded *mukozuke* with decoration of young pine tree and grasses.
226: *h4.5 w12.9×17.7*

227
Reshaped wheel-thrown *mukozuke* with decoration of shrimps and water weeds.
227: *h4.8 fw14.0×15.0*

228
Reshaped wheel-thrown *mukozuke* with decoration of fan-shaped palm leaf.
228: *h5.2 w9.8×14.5 bd8.2*

229–231
Reshaped wheel-thrown *mukozuke*, decorated with variations of the same pattern of grasses overhanging a basket-work cage.
229: *h5.1 w14.6* 230: *h5.0 w15.5*
231: *h4.3 w13.8*

232
Moulded *mukozuke* with decoration of bush clover and small birds.
232: *h4.5 w14.4*

233
Moulded *mukozuke* with decoration of pine trees and lines.
233: *h4.1 w11.2×17.0*

234
Moulded *mukozuke* with decoration of gourds in line and wash.
234: *h5.2 w11.0×12.5*

235
Moulded *mukozuke* with decoration of simplified pine trees in profile on a hill side. This represents a later style.
235: *h4.7 fw12.0×13.4*

DEEP MUKOZUKE

236
Large reshaped wheel-thrown *mukozuke*, with interior decoration of heron among reeds (slightly underfired).
236: *h6.5 fw12.0×14.0*

237
Squared wheel-thrown *mukozuke* with exterior decoration of bridge.
237: *h7.0 w11.2 bd6.7*

238
Stepped wheel-thrown *mukozuke* with indented upper part. Geometric and floral scroll decoration.
238: *h9.3 w9.2 bd5.2*

239
Wheel-thrown *mukozuke* with floral and abstract pattern.
239: *h10.0 md9.5 bd7.0*

240
Wheel-thrown *mukozuke* with everted lip and decoration of basket-work cage and grasses.
240: *h10.0 d9.5 bd6.9*

241
Wheel-thrown *mukozuke* with everted lip and decoration of grasses and plants.
241: *h9.8 d9.0 bd6.5*

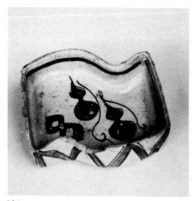

234

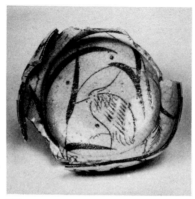

236

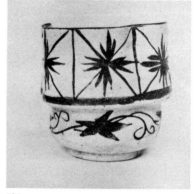

238

TALL MUKOZUKE

242
Wheel-thrown *mukozuke* with decoration of creeping plants.
242: *h9.3 d6.4 md7.5 bd5.6*

243
Wheel-thrown *mukozuke* with geometric patterns.
243: *h11.9 d6.6 bd5.7*

244
Wheel-thrown *mukozuke* with decoration of circumferential rings.
244: *h9.9 d6.7 bd5.3*

245
Wheel-thrown *mukozuke* decorated with vertical arrows and rings.
245: *h12.0 d7.0 bd5.6*

246
Wheel-thrown *mukozuke* with plant designs on abstract background.
246: *h10.2 d6.1 bd5.0*

247
Moulded triangular *mukozuke* with geometric and lattice patterns in line and wash.
247: *h11.0 w6.6*

BOTTLE

248
Long-necked bottle with flowering plant design.
248: *md 11.0*

EWER

249
Spouted ewer, formerly with handle and lid. Decoration of a willow tree.
249: *h10.0 d6.8 bd5.6*

POTICHE

250
Potiche with rounded shoulder, narrow neck and floral design.
250: *h6.7 d6.4 md7.7*

SMALL LID

251
Lid, probably intended for a small jar or tea caddy.
251: *h2.1 d4.7*

FIGURE OF AN OWL

252
Modelled owl, possibly the upper part of an incense box.
252: *h4.0 w3.0*

OIL LAMPS

253
Base, lamp and lid with decoration of trailing vine.
253: *h5.5 d15.8 bd7.5 (d and bd of dish)*

254
Lamp, with handle, showing the slope for the wick. Leaf decoration in line and wash.
254: *h4.6 w8.6–8.8 bd5.2*

255
Lid for a lamp with diamond patterns in line and wash.
255: *h2.9 d7.8*

256
Lid, either for a lamp of for an incense burner, pierced as a cherry blossom.
256: *h2.5 d6.2*

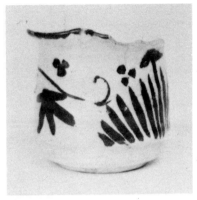

241

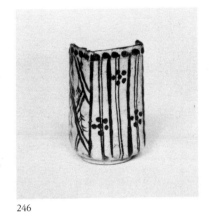

246

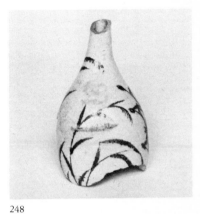

248

SHINO-ORIBE STYLE WARES

257–261

Simple everyday functional wares in Shino Oribe style. These are found at most kilns but are typical of the peripheral kilns and of the later phases of the central kilns.

257: *h3.3 d15.0 bd8.6*
258: *h2.8 d11.7 bd7.2*
259: *h2.9 d12.8 bd8.1*
260: *h2.5–2.9 d12.3–12.6 bd7.2*
261: *h3.0 d12.7 bd8.0*

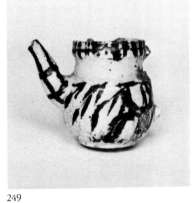

249

252

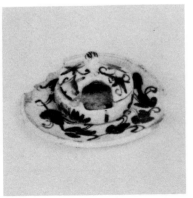

253

261

GREEN ORIBE, RED ORIBE AND NARUMI ORIBE WARES

As Shino wares are the climax of the *ōgama* manufacture, so Green Oribe wares are the finest achievement of the early Mino *noborigama.* These wares are characterised by asymmetry of shape and design and by the copper green glaze which covers only part of each piece. In some cases the eccentricity is heightened by the use of different coloured slips for decoration or even by different coloured clays for the body; such pieces are known as Narumi Oribe. When no green glaze is used, the pink appearance causes the pieces to be referred to as Red Oribe.

262

271

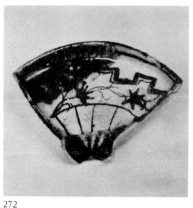

272

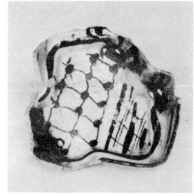

273

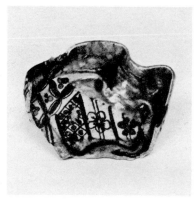

274

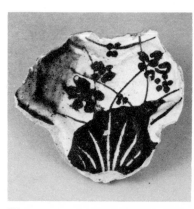

279

PLATE VII

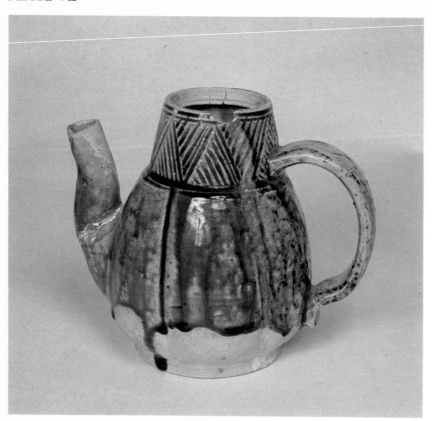

330

Monochrome Oribe ewer with band of incised hatched triangles around neck

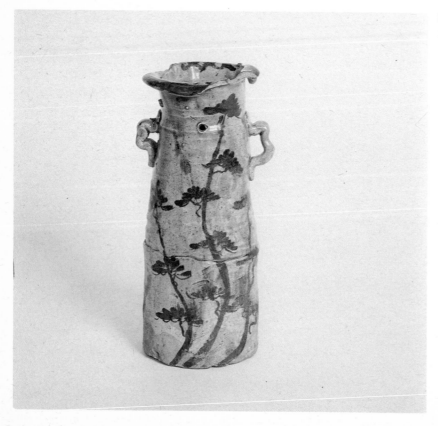

337

Mino Karatsu vase with decoration of pine tree and grasses

PLATE VIII

348

Caramel-glazed jar with lug handles on shoulder and matching lid (349)

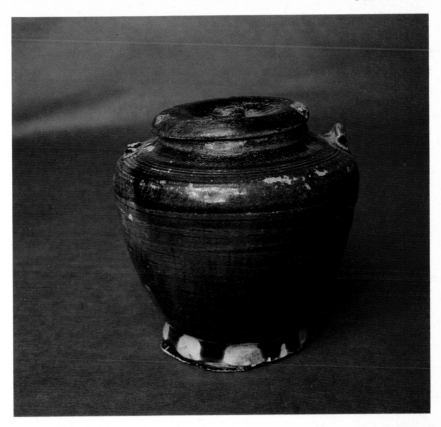

377

Ofuke fresh water jar with striated neck, fluted shoulders and flower-shaped handles

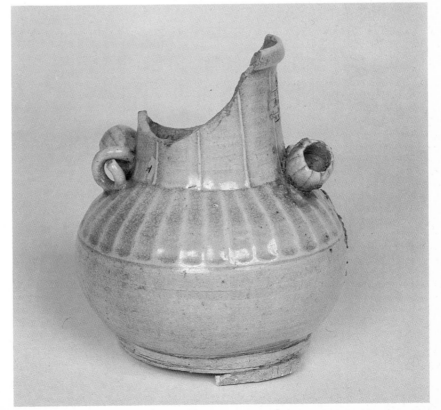

280

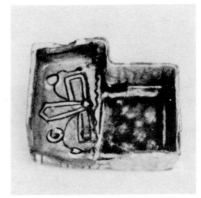

284

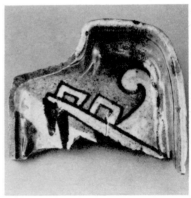

286

LARGE BOWL

262

Red Oribe bowl, the flattened rim with a dotted pattern, the interior with abstract leaves and a medallion and the exterior with a flower scroll.
262: *h8.0 d21.8–22.1 bd13.2*

LARGE DISH

263

Large flat Green Oribe dish with decoration of fallen plum blossoms floating on a stream.
263: *h7.8 w29.0 bd16.0*

DISHES WITH OVERHEAD HANDLES

264–265

Fragments of large Narumi Oribe dishes.
264: *h7.4 fw15.3*
265: *h4.3 fw10.5 × 10.5*

266

Small Narumi Oribe dish.
266: *h6.1 w9.4 × 12.2*

267–270

Examples of handles of different shapes.
267: *fl11.4* 268: *fl12.6* 269: *fl9.1*
270: *fl8.1*

FLAT MUKOZUKE

271–283

Green Oribe flat *mukozuke*. These are all mould-made (contrast Shino Oribe wares nos. 225–235). The patterns on Green Oribe wares are less strictly figurative than those found on Shino Oribe wares.
271: *h4.8 fw11.8*
272: *h4.4 w13.4 × 16.9*
273: *h5.5 fw12.8*
274: *h5.0 w10.5 × 13.5*
275: *h4.6 w11.5 × 13.0*
276: *fh4.4 w11.4 × 13.5*
277: *h5.1 w13.0 × 14.4*
278: *h5.0 w12.0 × 13.2*
279: *fh3.9 fw10.6 × 12.6*
280: *h4.1 fw10.5 × 11.1*
281: *h4.6–4.9 fw12.1*
282: *fh3.2 fw12.2–12.6*
283: *h4.2 w10.3 × 15.4*

284–287

Narumi Oribe flat *mukozuke*. Mould-made in different coloured clays, the designs tend to be highly abstract.
284: *h4.6 w10.5 × 12.8*
285: *h4.4 fw10.9 × 12.6*
286: *h5.0 fw8.8 × 10.7*
287: *h5.2 fw9.2 × 10.3*

288

Round flat *mukozuke* in an unusual technique related to Red Oribe. Design in underglaze iron of a sage on a donkey in Chinese style.
288: *fh4.5 fw13.9 × 14.0 bd8.5*

DEEP MUKOZUKE

289

Green Oribe *mukozuke* with fluted vertical sides and interior and exterior patterning.
289: *h7.0 bd7.3*

290

296

299

TALL MUKOZUKE

290–293
Wheel-thrown or moulded Green Oribe *mukozuke* with more or less vertical sides.
290: *h10.6 d6.2 bd5.5*
291: *h10.8 w5.3 bd5.6*
292: *h9.5 w5.2 bd4.2*
293: *h9.6 w8.0 bd5.6*

294–297
Moulded Narumi Oribe *mukozuke* with more or less vertical sides.
294: *h10.2 w6.0*
295: *h10.3 w5.6*
296: *h9.3 w8.0 bd6.0*
297: *fh6.9 fw6.5 bd4.8*

STEPPED MUKOZUKE

298
Wheel-thrown and stepped Green Oribe *mukozuke* with decoration of plum blossoms.
298: *h9.2 w10.6 bd5.9*

MUKOZUKE WITH STEMS

299–301
Wheel-thrown and reshaped Green Oribe *mukozuke* with various designs.
299: *h8.2 w8.8 bd5.2*
300: *h9.0 d9.0 bd5.8*
301: *h8.7 d9.9 bd6.3*

LIDS OF FAN SHAPED BOXES

302
Green Oribe lid with stamped patterning and applied modelled branch as a handle.
302: *fh3.3 fw14.7×15.2*

303
Red Oribe lid with birds in a tree partly modelled as the handle, grasses and blossoms.
303: *h5.3 w20.1*

EWER

304
Green Oribe ewer, formerly with handle and lid. Lattice decoration.
304: *h11.4 d6.0 bd6.9*

INCENSE BURNERS

305–307
Wheel-thrown Green Oribe incense burners of various cylindrical shapes, with straight thick lips.
305: *h10.3 d7.0 md5.5 bd5.5*
306: *h9.3 d6.6 md8.0 bd5.5*
307: *h9.3 d7.7 bd6.0*

INCENSE BOXES

308–313
Various Green Oribe incense boxes, 308 being the only complete example.
308: *h2.9 w5.4* 309: *h1.5 w5.5*
310: *h2.1 w3.3 bd3.6* 311: *h1.8 d5.2*
312: *h2.0 d4.3 bd3.1*
313: *h1.8 w3.2×4.2*

SMALL LID

314
Small Green Oribe lid for a jar or tea caddy.
314: *h2.1 d5.0*

300

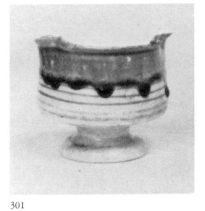

301

304

OIL LAMPS

315
Green Oribe lampstand.
315: *fh9.7 d5.7 bd6.2*

316
Green Oribe base of a lamp.
316: *h1.5 d14.5 bd7.7*

317
Green oribe lid for a lamp.
317: *h3.0 d7.8*

Shapes not represented here include tea bowls, fresh water jars, *namban* candle-stands, bottles and ewers with overhead handles.

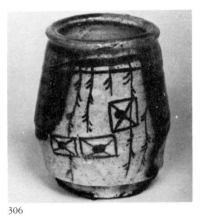

306

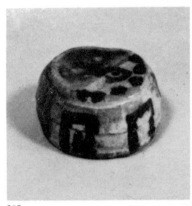

308

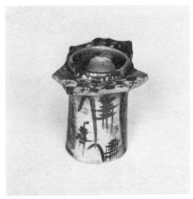

315

317

75

The word Oribe is applied to these wares solely on account of the green glaze. Decoration is confined to stamped patterns, incised drawing and moulding. The shapes are never particularly eccentric and in no way resemble Green Oribe wares. They should not be considered as "tea-related wares" but more as functional wares of the same type as Ofuke and iron-glazed wares (see p. 36).

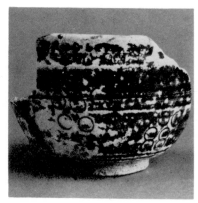

318

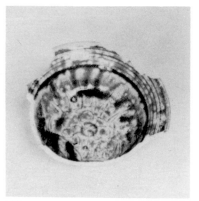

320

BOWL

318
Round bowl with stamped circles in irregular groups.
318: *h7.5 d11.7 bd5.1*

DISHES

319
Plain dish with flat rim.
319: *h3.0–3.3 d14.7 bd7.3*

320–322
Dishes with flat rims and incised decoration.
320: *h5.8 d14.5 bd6.3*
321: *h3.8 fw11.0 × 12.5 bd7.0*
322: *fh3.5 bd8.9*

323
Wheel-thrown and subsequently moulded dish.
323: *h4.7 d15.3 bd7.5*

324
Moulded dish in the form of a lotus leaf, with attached feet.
324: *h2.8–4.0 fw13.3*

325
Unavailable for exhibition.

INK STONE

326
Ink stone of rounded cruciform shape with surround of stamped and applied decoration.
326: *h3.5 d13.4–16.9*

WATER DROPPR

327
Small water dropper with petal-shaped top and stamped decoration.
327: *h3.0 md5.0 bd3.5*

MODEL OF A SHISHI

328–329
Modelled *shishi*, possibly a water dropper.
328: *fh3.7* 329: *w4.0*

EWER

330
Spouted ewer with raised neck and gallery for a lid.
330: *h17.2 d6.6. md12.8 bd9.6*

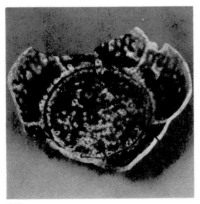

323

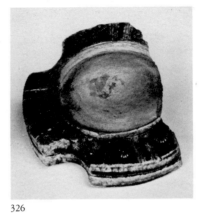

326

327

OIL LAMP LID

331
Lid with modelled knob.
331: *h3.1 d7.9*

BOWL FOR A PIPE

332
Ceramic pipe bowl.
332: *h4.3 w2.8×9.5*

328

329

The Mino *noborigama* are remarkable for the imitations they made of "tea-related wares" produced at rival kilns in Iga, Bizen and Karatsu. The connection between Mino and Karatsu was already established in the late 16th century, and it is thought that the technology of the *noborigama* was originally introduced to Mino from Karatsu. The connection with Iga and Bizen is less well understood.

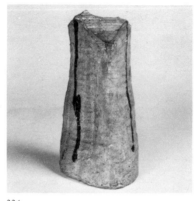

334

335

MINO IGA WARES

333
Tall vase with handles, extensive modelling and roughly textured surface covered in powdery white glaze (underfired).
333: *h25.8 bd12.4*

334
Tall tapering vase, square in shape, with irregular streaks of powdery white and brown glaze (underfired).
334: *fh24.4 bd12.0*

335–336
Fresh water jar. Strongly distorted body with horizontal striations, roughly attached handles and modelled base. The lip rolls inwards to receive a lid (336), while the streaks of white and brown glaze imitate the effect of the natural ash glaze found on Iga wares.
335: *figures not available at time of printing*
336: *h4.1 d11.3*

MINO KARATSU WARES

337
Tall vase with everted, foliated lip and two handles. The colour of the glaze and the pine tree design strongly resemble Karatsu wares. The small holes at the neck may have been for the purpose of suspending the vase.
337: *h29.9 d11.8 md12.7 bd11.6*

338
Small bowl, round in shape and with a tall foot. The exterior is decorated with autumn grasses under a sombre greyish glaze.
338: *fh6.6 md9.8 bd5.4*

339
Mukozuke with flaring sides and foliated rim. Decoration of birds over pine-clad mountains.
339: *h4.4–5.0 d14.4 bd6.5*

340
Deep *mukozuke* with everted lip and decoration of flower scroll.
340: *h7.2 d13.3 bd8.0*

339

340

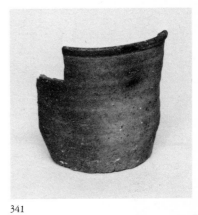

341

MINO BIZEN WARES

341
Tall cylindrical fresh water jar with slightly inward-turning lip, intended for a lid. In the kiln it was used as a saggar. Made of a clay with a high iron content and unglazed.
341: *h16.0 bd13.4*

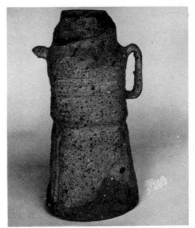

333

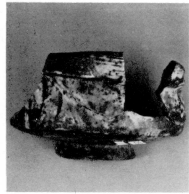

344

342
Round bowl with flaring sides, decorated with white slip and iron-painted stripes.
342: *h4.8 d15.9 b7.2*

343
Fragment of *mukozuke* with complex lip in a style related to Mino Karatsu wares.
343: *fw5.2×6.7*

344–345
Tea bowls made of clay with a high iron content that fires black. The glaze of no. 344 resembles that of Shino wares, while no. 345 is so overfired as to be difficult to classify.
344: *h6.3 w13.2×14.4 bd5.7*
345: *fh5.4 fw11.9 bd6.5*

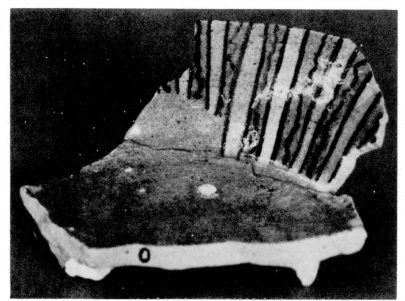

342

The caramel glazed wares of this group represent a new type of glaze and range of shapes. They are almost always functional or ceremonial wares and the glaze is typically thin, evenly distributed and rather glassy. Other wares in the group include a matt iron glaze that imitates cast iron, and the standard iron glaze of Temmoku tea bowls and tea caddies.

347

350

CARAMEL GLAZE

346–347
Buddhist flower vases.
346: *h16.0 d6.6 md10.0 bd7.0*
347: *h12.2 d10.6 bd5.5*

348–349
Lidded jar with lug handles on the shoulder.
348: *h10.7 d7.0 md12.0 bd7.6*
349: *h8.7 d4.6 md8.4 bd6.2*

350–352
Spouted ewers with handles and lids.
350: *h2.1 d7.6* 351: *h2.0 d4.7*
352: *h1.3 d3.2*

353–354
Small bottles, no. 354 in the shape of a gourd.
353: *fh7.5 md5.7 bd3.9*
354: *h7.7 md5.4 bd3.8*

355–356
Shallow oil lamps, with a handle at one side and a cut-away section of the lip opposite.
355: *h2.3 d9.4 bd3.6*
356: *h2.0 d10.6 bd6.5*

353

355

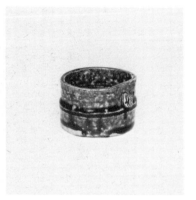

357

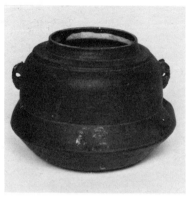

358

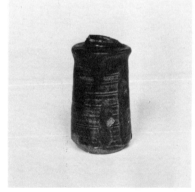

360

357

Lid-rest shaped as a node of bamboo. A rare example of the use of this glaze on tea ceremony wares.
357: *h4.6 d6.5–7.2*

MATT IRON GLAZE

358

Kettle, closely modelled on a cast iron original, with a pair of lateral lug handles.
358: *h14.6 d10.6 md21.0 bd12.2*

STANDARD IRON GLAZE

359–360

Temmoku tea bowls. The earlier Temmoku tea bowls to be made at Motoyashiki were low and squat like those of late *ōgama* (359), but subsequent examples were tall with a clearly defined footring, typical of other Mino *noborigama* (360).
359: *h5.8 d11.8 bd4.1*
360: *h7.0 d12.5 bd4.6*

361–362

Tea caddies. Wheel-thrown with subsequent purposeful misshaping. No. 362 is made from a highly iron-bearing clay, and both examples are iron glazed.
361: *h10.3 d3.5 bd4.5*
362: *h9.6 d3.2 bd5.3*

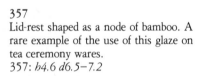

361

Although these attractive and well-made wares were made in the Oribe producing kilns of Kujiri, they differ markedly in style from Oribe wares and are in fact descended from Ash Shino wares (see p. 22). They are evenly covered in a grey-green glaze, with a fine crackle over a hard grey body. Frequently moulded into elaborate shapes, they may have carved decoration or underglaze iron painting which is often applied with the use of a stencil. From the last phases of Motoyashiki there was an attempt to imitate Blue and White porcelains. The quality of the almost white body varies considerably as does the colour of the underglaze blue.

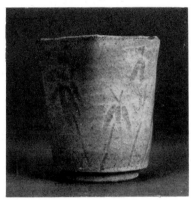

366

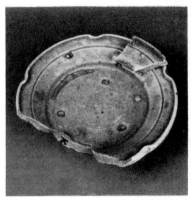

368

BOWLS AND CUPS

363
Round bowl with attached foot.
363: *h6.9 d10.8 bd5.6*

364
Small round bowl with attached foot.
364: *h5.0 d8.8 bd4.8*

365
Cup with a strongly everted lip and splashed iron-brown decoration.
365: *h4.9 d2.3 bd4.6*

366
Tall wheel-thrown cup, subsequently moulded into a pentagonal shape, with incised decoration of bamboo and grasses.
366: *h7.7 w6.6 bd4.2*

367
Food bowl for a bird-cage.
367: *h3.1 d5.6 bd4.2*

DISHES

368–369
Wheel-thrown dishes. No. 368 has a foliated rolled lip, while no. 369 has everted sides with incised floral scroll decoration.
368: *h2.9 d13.4 bd7.5*
369: *h4.3 d15.1 bd7.0–7.3*

370
Deep moulded dish in five-petalled form.
370: *h4.9–5.3 d14.6 bd6.7*

371
Moulded dish in the shape of a chrysanthemum and leaves, with three attached peg feet.
371: *h2.9–4.0 fw12.9×13.6*

372
Rectangular moulded dish with lotus decoration and three attached peg feet.
372: *h3.2–3.5 w10.0×13.1*

373–374
Miniature dishes, moulded, no. 373 in the shape of a flower, no. 374 in the shape of a lozenge, each with three attached peg feet.
373: *h2.3 fw6.0×6.5*
374: *h1.9–2.2 fw6.6×7.5*

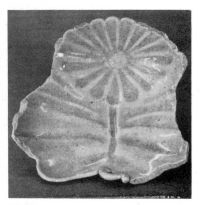

371

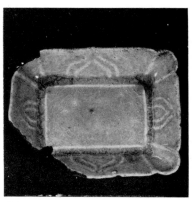

372

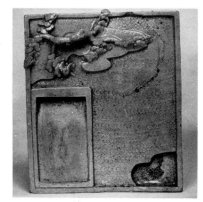

378

LARGE DISH

375
Large dish with carved lotus centre, wave pattern sides and simple rim.
375: *5.2–6.7 d27.2 bd19.6–20.1*

VASE

376
Vase with stepped body, fluted neck and small lateral lug handles, probably formerly with a wide flaring lip (see nos. 348 & 349).
376: *fh15.7 md10.3 bd7.3*

FRESH WATER JAR

377
Fresh water jar of bulbous form with tall striated neck, fluted shoulders and two rolled handles in the shape of flowers.
377: *h18.0 md16.0 bd12.0*

INK STONE

378
Elaborately modelled ink stone.
378: *h5.5 w20.3×23.0*

WATER DROPPERS

379–381
Water droppers in various shapes, no. 379 as two flowers, no. 380 as a fish and no. 381 in a lozenge form.
379: *h3.2 w4.5×9.3*
380: *h6.0 w5.0×13.0*
381: *h2.4 w4.7×7.3*

LIDS

382–384
Lids of various sizes for use with jars, ewers and small containers.
382: *h2.3 d13.5* 383: *h2.0 d7.7*
384: *h1.5 d4.3*

CONTAINERS FOR HAIRPINS

385–386
Oval shaped containers with stencilled designs of maple leaves or chrysanthemums in underglaze iron.
385: *h4.5 w4.3×11.8*
386: *h4.5 w4.3×13.0*

OIL BOTTLE

387
Small oil bottle with cherry blossom design in underglaze iron.
387: *h6.5 md7.8 bd5.2*

INCENSE BURNER

388
Incense burner with vertical sides, rolled flattened lip and three small attached feet, decorated in a stencilled pattern in underglaze iron.
388: *h4.9 d9.8 bd6.3*

WHITE OFUKE WARES AND UNDERGLAZE COBALT

389
Round flat dish with underglaze cobalt decoration of a dog (clearly descended from a Wan Li original).
389: *fw12.0–13.6 bd10.7*

390
Deep cylindrical bowl with underglaze cobalt decoration of round *mon* and abstract patterns in a style reminiscent of Shonzui wares.
390: *h8.2 d10.5 bd7.0*

379

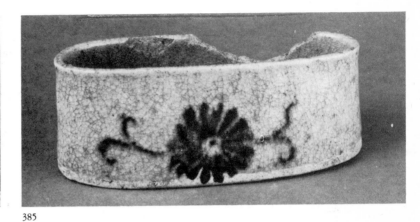

385

391
Flat lid with snail-shaped handle and flower decoration in underglaze cobalt.
391: *h3.0 d14.5*

392–393
Examples of the whitest body and glaze achieved at early Mino *noborigama*. No. 392 is a flat dish with foliated lip and deep fluted sides, no. 393 a simple dish with everted lip.
392: *d19.6* 393: *h2.6–2.9 d14.8 bd8.2*

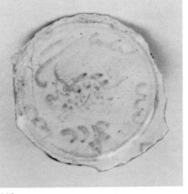

389

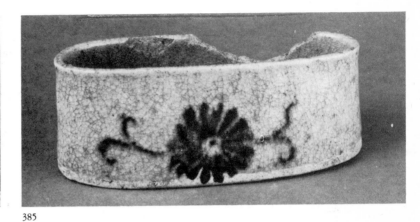

376

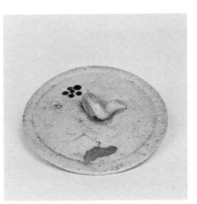

391

With the emergence of Oribe wares and perhaps even more so with Ofuke wares there was a great increase in the variety and complexity of kiln furniture used within saggars.

394

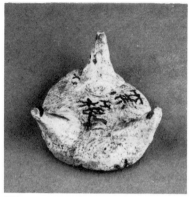

397

STILTS AND SPURS

394–397
Solid discs with varying numbers of attached spurs.
394: *h2.3 d11.9* 395: *h1.7 d8.8*
396: *h1.2 d5.7* 397 *h2.8 d5.2–5.5*

398
Ring with three attached spurs.
398: *h1.9 d6.8*

399
Single large conical spur.
399: *h2.3 d3.1*

400–402
Stilts of varying diameter and height.
400: *h3.5 d6.9–7.2* 401: *h4.3 d3.9*
402: *h0.8–1.3 d5.7–6.1*

STACKING OF WARES

403
Two dishes similar to no. 234 stacked with the use of a tall disc with tall spurs (397) and a ring (402).
403: *fh7.5 fw9.1 × 12.8*

404
Tall *mukozuke* (e.g. no. 293) placed in a saggar without the use of rings or spurs. As the saggar is a large one, there were probably three of more *mukozuke* within it.
404: *fh8.3 w (mukozuke) 7.9*
 bd (mukozuke) 6.3

398

400

404

BOOKS IN ENGLISH FOR FURTHER READING

Castile, Rand.
The Way of Tea. Tokyo and New York, Weatherhill, 1971.

Cort, Louise.
Shigaraki, Potters' Valley. Tokyo, New York and San Francisco, Kodansha International, 1979.

Fujioka, Ryōichi.
Tea Ceremony Utensils. Trans. by Louise Cort. Arts of Japan, vol. 3., Tokyo and New York, Weatherhill and Shibundo, 1973.

Hayashiya, Tatsusaburō; Nakamura, Masao; Hayashiya, Seizō.
Japanese Arts and the Tea Ceremony. Trans. by Joseph Macadam. Heibonsha Survey of Japanese Art, vol. 15. Tokyo and New York, Weatherhill and Heibonsha, 1974.

Jenyns, Soame.
Japanese Pottery. London, Faber and Faber, 1971.

Mikami, Tsugio.
The Art of Japanese Ceramics. Trans. by Ann Herring. Heibonsha Survey of Japanese Art, vol. 29. Tokyo and New York, Weatherhill and Heibonsha, 1973.

Sanders, Herbert H.
The World of Japanese Ceramics. Tokyo and New York, Kodansha International, 1967.

Sen, Soshitsu.
Chado, The Japanese Way of Tea. New York, Tokyo and Kyoto, Weatherhill and Tankosha, 1979.

Simpson, Penny; Kitto, Lucy; Sodeoka, Kanji.
The Japanese Pottery Handbook. Tokyo, New York and San Francisco, Kodansha International, 1979.

Tanaka, Sen'o.
The Tea Ceremony. Tokyo and New York, Kodansha International, 1973.

Tsuji, Kaichi.
Kaiseki: Zen Tastes in Japanese Cooking. Tokyo and New York, Kodansha International, 1972.

MAJOR JAPANESE WORKS ON MINO WARES

Arakawa, Toyozō.
Shino. Tōki Zenshū, vol. 4. Tokyo, Heibonsha, 1959.

Arakawa, Toyozō.
Shino, Kiseto, Setoguro. Tōji Taikei, vol. 11. Tokyo, Heibonsha, 1972.

Fujioka, Ryōichi.
Oribe. Tōji Taikei, vol. 12. Tokyo, Heibonsha, 1978.

Furukawa, Shōsaku.
Kiseto, Setoguro. Nihon no Yakimono, vol. 13. Tokyo, Kōdansha, 1975.

Furukawa, Shōsaku.
Mino. Nihon no Yakimono, vol. 12. Kyoto, Tankōsha, 1974.

Hayashiya, Seizō, ed.
Shino. Nihon no Tōji, vol. 2. Tokyo, Chūō Kōronsha, 1974.

Hayashiya, Seizō, ed.
Kiseto, Setoguro. Nihon no Tōji, vol. 3. Tokyo, Chūō Kōronsha, 1974.

Hayashiya, Seizō, ed.
Oribe. Nihon no Tōji, vol. 4. Tokyo, Chūō Kōronsha, 1974.

Hayashiya, Seizō, ed.
Shino. Nihon Tōji Zenshū, vol. 15. Tokyo, Chūō Kōronsha, 1975.

Hayashiya, Seizō, et al.
Momoyama II. Sekai Tōji Zenshū, vol. 5. Tokyo, Shogakkan, 1976.

Kuroda, Ryōji.
Shino. Nihon no Yakimono, vol. 11. Tokyo, Kōdansha, 1975.

Mitsuoka, Tadanari, et al.
Momoyama. Sekai Tōji Zenshū, vol. 3. Tokyo, Kawade Shobō, 1956.

Mitsuoka, Tadanari, et al.
Chaki. Sekai Tōji Zenshū, vol 7. Tokyo, Kawade Shobō, 1956.

Mitsuoka, Tadanari, et al.
Nihon II, Momoyama. Tōki Kōza, vol. 2. Tokyo, Yuzankaku, 1972.

Murayama, Takeshi.
Oribe. Nihon no Yakimono, vol. 12. Tokyo, Kōdansha, 1976.

Narasaki, Shōichi.
Shirashi. Nihon Tōji Zenshū, vol. 6. Tokyo, Chūō Kōronsha, 1976.

Narasaki, Shōichi.
Seto, Mino. Nihon Tōji Zenshū, vol. 9. Tokyo, Chūō Kōronsha, 1976.

Narasaki, Shōichi.
Seto, Bizen, Suzu. Book of Books, Nihon no Bijutsu, vol. 43. Tokyo, Shogakkan, 1976.

Narasaki, Shōichi; Mino Kotō Kenkyūkai.
Mino no Kotō. Kyoto, Kōrinsha, 1976.

Narasaki, Shōichi, et al.
Nihon Chūsei. Sekai Tōji Zenshū, vol. 3. Tokyo, Shogakkan, 1977.

Takeuchi, Junichi.
Kiseto, Setoguro. Nihon Tōji Zenshū, vol. 14. Tokyo, Chūō Kōronsha, 1977.

Takeuchi, Junichi.
Oribe. Nihon Tōji Zenshū, vol. 16. Tokyo, Chūō Kōronsha, 1976.

EXCAVATION REPORTS OF 16th AND 17th CENTURY MINO KILN SITES

Kankō Shigen Hogo Zaidan. *Mino Koyōsekigun.* 1976.

Kasahara-chō Kyōiku Iinkai. *Myōdo Yōseki Hakkutsu Chōsa Hōkoku.* 1976.

Mizunami-shi Kyōiku Iinkai. *Ōgawa Higashi Yō.* 1979.

Tajimi-shi Kyōiku Iinkai. *Tajimi no Koyō*, vol. 1. 1976.

Toki-shi Kyōiku Iinkai. *Toki-shi Chūō Jidōshadō Kankei Iseki,* (inc. reports on Maruishi Higashi, Seianji, Jōrinji Nishibora nos. 1, 2 and 3, Jōrinji Higashibora nos. 1, 2 and 3). 1971.

Toki-shi Kyōiku Iinkai. *Kamagane Koyōshi.* 1970.

KILN SITE→SHARD INDEX

Key
M1 Maruishi no. 1
M2 Maruishi no. 2
M3 Maruishi no. 3
TN Tsumagi Nishiyama
TK5 Tsumagi Kamashita no. 5
A Anakōbo
H Hinata
T Tōshirō
JH1 Jōrinji Higashibora no. 1
MH Maruishi Higashi
JN1 Jōrinji Nishibora no. 1
Mo Motoyashiki
IN Inkyo Nishi
ON Ōtomi Nishi
So Sonodogawa
K Kamagane
Se Seianji

M1 nos. 1, 2, 6, 11 and 13
M2 nos. 3, 5, 7−10 and 12
M3 nos. 14−16, 18 and 19
TN nos. 20, 25 and 35
TK5 nos. 26, 30, 32, 38, 40, 41 and 44
A no. 36
H no. 42
T no. 45
JH1 nos. 46, 48−50, 52, 63−72, 74, 75, 77−81 and 86−90
MH nos. 47, 51, 53−62, 73, 76, 82−85 and 91−100
JN1 nos. 102, 105, 106 and 141−148
Mo nos. 110, 112, 113, 115−118, 124, 125, 131−140, 149, 152, 163,
 172, 173, 179, 192, 193, 201, 215, 216, 218, 219, 224, 226,
 228−231, 233, 234, 238−240, 242−244, 246−249, 251, 253, 255,
 257, 259, 261, 265, 266, 272−275, 277, 278, 284, 289−292, 294,
 295, 298, 299, 301, 303−308, 311−315, 322, 326, 332−334, 336,
 337, 340, 341, 346, 353−355, 357−359, 361, 362, 377, 380, 386,
 387 and 391
IN nos. 163a and 203−206
ON no. 202
So no. 212
K nos. 222, 235, 267, 269, 270, 283, 288, 297, 320, 321, 323, 339,
 347, 368, 371, 373−376, 378, 389, 390, 392−394, 396 and 397
Se nos. 324, 369 and 370

SHARD→KILN SITE INDEX

Key
M1	Maruishi no. 1
M2	Maruishi no. 2
M3	Maruishi no. 3
TN	Tsumagi Nishiyama
TK5	Tsumagi Kamashita no. 5
A	Anakōbo
H	Hinata
T	Tōshirō
JH1	Jōrinji Higashibora no. 1
MH	Maruishi Higashi
JN1	Jōrinji Nishibora no. 1
Mo	Motoyashiki
IN	Inkyo Nishi
ON	Ōtomi Nishi
So	Sonodogawa
K	Kamagane
Se	Seianji

1	M1	45	T	91	MH	135	Mo
2	M1	46	JH1	92	MH	136	Mo
3	M2	47	MH	93	MH	137	Mo
4	—	48	JH1	94	MH	138	Mo
5	M2	49	JH1	95	MH	139	Mo
6	M1	50	JH1	96	MH	140	Mo
7	M2	51	MH	97	MH		
8	M2	52	JH1	98	MH	141	JN1
9	M2	53	MH	99	MH	142	JN1
10	M2	54	MH	100	MH	143	JN1
11	M1	55	MH	101	—	144	JN1
12	M2	56	MH	102	JN1	145	JN1
13	M1	57	MH	103	—	146	JN1
		58	MH	104	—	147	JN1
14	M3	59	MH	105	JN1	148	JN1
15	M3	60	MH	106	JN1	149	Mo
16	M3	61	MH			150	—
17	—	62	MH	107	—	151	—
18	M3	63	JH1	108	—	152	Mo
19	M3	64	JH1	109	—	153	—
		65	JH1	110	Mo	154	—
20	TN	66	JH1	111	—	155	—
21	unavailable	67	JH1	112	Mo	156	—
22	—	68	JH1	113	Mo	157	—
23	—	69	JH1	114	—	158	—
24	—	70	JH1	115	Mo	159	—
25	TN	71	JH1	116	Mo	160	—
26	TK5	72	JH1	117	Mo	161	—
27	—	73	MH	118	Mo	162	—
28	—	74	JH1	119	—	163	Mo
29	—	75	JH1	120	—	163a	IN
30	TK5	76	MH	121	—	164	—
31	—	77	JH1	122	—	165	—
32	TK5	78	JH1	123	—	166	—
33	—	79	JH1			167	—
34	—	80	JH1	124	Mo	168	—
35	TN	81	JH1	125	Mo	169	—
36	A	82	MH	126	—	170	—
37	—	83	MH	127	—	171	—
38	TK5	84	MH	128	—	172	Mo
39	—	85	MH	129	—	173	Mo
40	TK5	86	JH1	130	—	174	—
41	TK5	87	JH1	131	Mo	175	—
42	H	88	JH1	132	Mo	176	—
43	—	89	JH1	133	Mo	177	—
44	TK5	90	JH1	134	Mo	178	—

179 Mo	224 Mo	269 K	315 Mo	357 Mo	404 —
180 —	225 —	270 K	316 —	358 Mo	
181 —	226 Mo	271 —	317 —	359 Mo	
182 —	227 —	272 Mo		360 —	
183 —	228 Mo	273 Mo	318 —	361 Mo	
184 —	229 Mo	274 Mo	319 —	362 Mo	
185 —	230 Mo	275 Mo	320 K		
186 —	231 Mo	276 —	321 K	363 —	
187 —	232 —	277 Mo	322 Mo	364 —	
188 —	233 Mo	278 Mo	323 K	365 —	
189 —	234 Mo	279 —	324 Se	366 —	
190 —	235 K	280 —	325 unavailable	367 —	
191 —	236 —	281 —	326 Mo	368 K	
192 Mo	237 —	282 —	327 —	369 Se	
193 Mo	238 Mo	283 K	328 —	370 Se	
194 —	239 Mo	284 Mo	329 —	371 K	
195 —	240 Mo	285 —	330 —	372 —	
196 —	241 —	286 —	331 —	373 K	
197 —	242 Mo	287 —	332 Mo	374 K	
198 —	243 Mo	288 K		375 K	
199 —	244 Mo	289 Mo	333 Mo	376 K	
200 —	245 —	290 Mo	334 Mo	377 Mo	
201 Mo	246 Mo	291 Mo	335 —	378 K	
202 ON	247 Mo	292 Mo	336 Mo	379 —	
203 IN	248 Mo	293 —	337 Mo	380 Mo	
204 IN	249 Mo	294 Mo	338 —	381 —	
205 IN	250 —	295 Mo	339 K	382 —	
206 IN	251 Mo	296 —	340 Mo	383 —	
207 —	252 —	297 K	341 Mo	384 —	
208 —	253 Mo	298 Mo		385 —	
209 —	254 —	299 Mo	342 —	386 Mo	
210 —	255 Mo	300 —	343 —	387 Mo	
211 —	256 —	301 Mo	344 —	388 —	
212 So	257 Mo	302 —	345 —	389 K	
213 —	258 —	303 Mo		390 K	
214 —	259 Mo	304 Mo	346 Mo	393 K	
	260 —	305 Mo	347 K		
215 Mo	261 Mo	306 Mo	348 —	394 K	
216 Mo		307 Mo	349 —	395 —	
217 —	262 —	308 Mo	350 —	396 K	
218 Mo	263 —	309 —	351 —	397 K	
219 Mo	264 —	310 —	352 —	398 —	
220 —	265 Mo	311 Mo	353 Mo	399 —	
221 —	266 Mo	312 Mo	354 Mo	401 —	
222 K	267 K	313 Mo	355 Mo	402 —	
223 —	268 —	314 Mo	356 —	403 —	

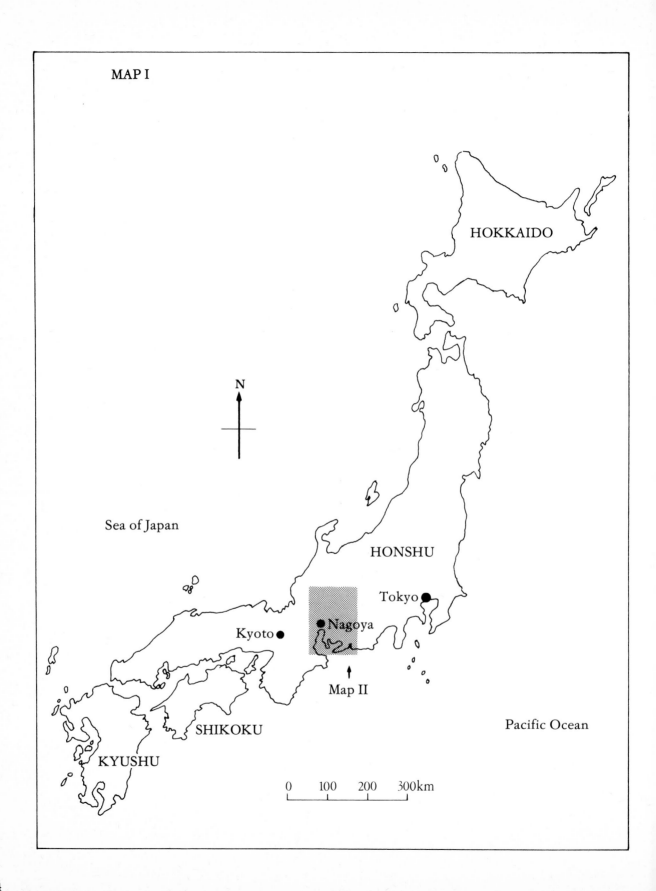

MAP I

HOKKAIDO

N

Sea of Japan

HONSHU

Tokyo ●

Kyoto ● ● Nagoya

Map II

SHIKOKU

Pacific Ocean

KYUSHU

0 100 200 300km

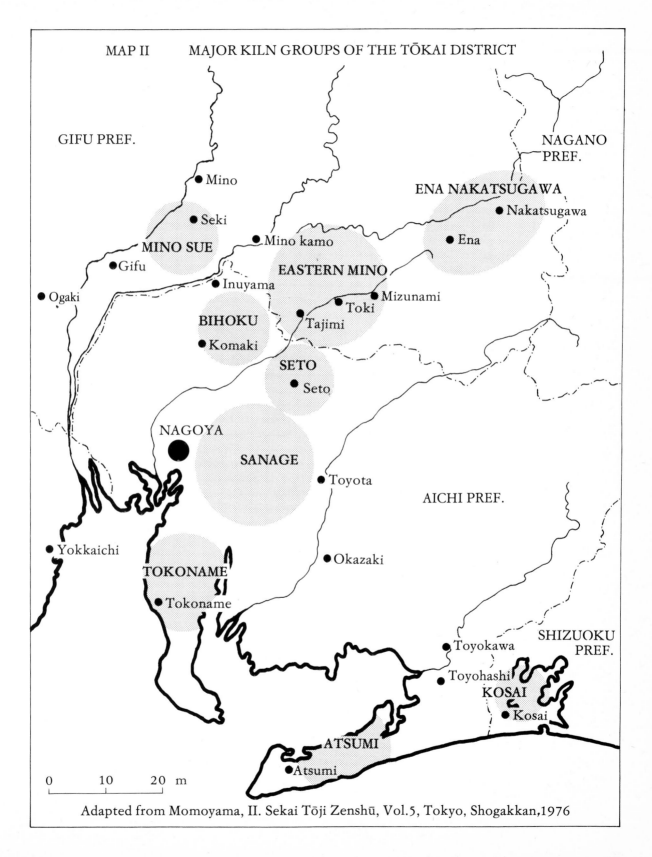

MAP II MAJOR KILN GROUPS OF THE TŌKAI DISTRICT

GIFU PREF.

NAGANO PREF.

ENA NAKATSUGAWA

• Mino

• Nakatsugawa

• Seki

• Ena

MINO SUE

• Mino kamo

• Gifu

EASTERN MINO

• Ogaki

• Inuyama

• Mizunami

BIHOKU

• Toki

• Tajimi

• Komaki

SETO

• Seto

NAGOYA

SANAGE

• Toyota

AICHI PREF.

• Yokkaichi

• Okazaki

TOKONAME

• Tokoname

• Toyokawa

SHIZUOKU PREF.

• Toyohashi

KOSAI

• Kosai

ATSUMI

• Atsumi

0 10 20 m

Adapted from Momoyama, II. Sekai Tōji Zenshū, Vol.5, Tokyo, Shogakkan,1976

INDEX TO MAP III KILN SITES

MAP III
THE EASTERN MINO KILN GROUP